Johannes Vermeer
(1632-1675)

Mariët Westermann

Waanders Publishers

Rijksmuseum, Amsterdam

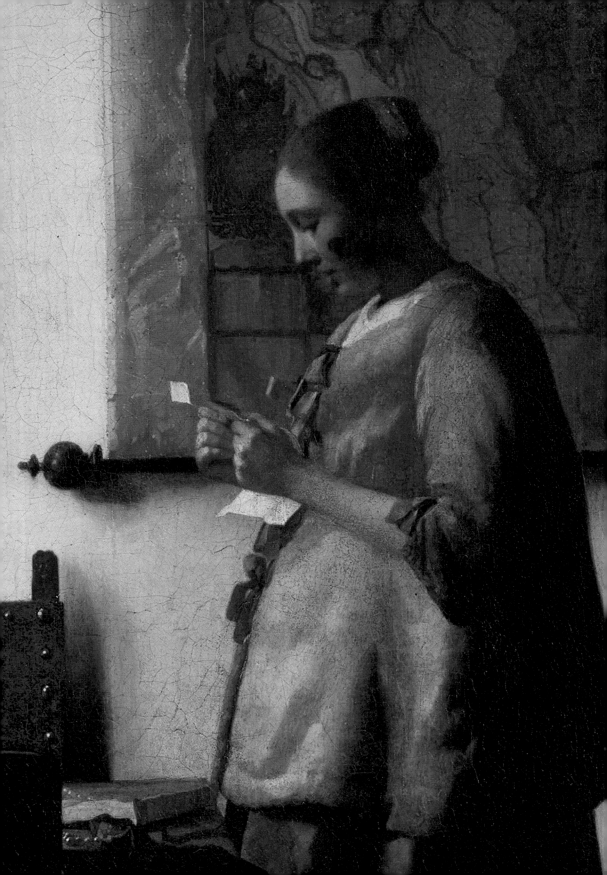

Contents

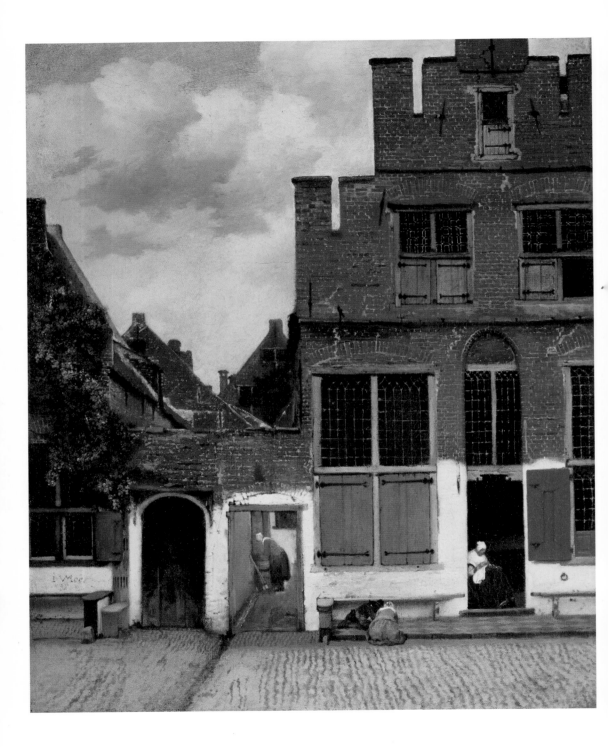

INTRODUCTION

Few paintings command our gaze as Vermeer's *Little street* does (fig. 1). In the Rijksmuseum gallery where the small canvas competes with charming genre scenes by Pieter de Hooch (figs. 2, 3), and, more seriously, with three of Vermeer's paintings of women in interiors, visitors look at *The little street* for minutes rather than the average five seconds per picture. The painting's hold on the viewer stems in the first instance from the pleasure of recognition: its fame has been assured by the infinite multiplication of its image since the late 19th century. But once caught, our eyes tend to linger, even though a quick inventory of what the painting represents amounts to the sort of scene most of us would brush by in life. We see *The little street* as a passer-by looking across a street at two gabled houses in some disrepair, connected by a shared wall between two alleys, one closed off by a battered wooden door. A jumble of gables and chimneys visible between the houses tells us that we are in a city. Two women are busy with their chores, two children kneel over a game. The painting is short on story, does not demand literary knowledge. *The little street*'s unassuming character and riveting lifelikeness prompt us to look at the painting as a painting.

Although the intimate exterior setting of *The little street* is unique in Vermeer's oeuvre, almost all of his 34 surviving paintings – including the three others now in the Rijksmuseum (figs. 7, 37, 42) – invite sustained scrutiny. The visual attentiveness they demand makes us aware that, although they appear to copy reality, they are very much products of art. The Rijksmuseum's Vermeers document the artist's career-long study of optical phenomena as a basis for art, from the early *Little street* and *Kitchen maid* through the *Woman reading a letter* of his middle career to the late *Love letter*. Vermeer applied his persuasive skills to a rigorously limited repertoire of themes, equally well exemplified in his paintings in the Rijksmuseum. His choices of settings, actors and props tell us much about the values and interests of his milieu in Delft, made up as it was of fellow artists and well-heeled customers. The Rijksmuseum's varied and extensive collection of paintings by Vermeer's peers makes for a stimulating environment in which to study his distinctive art and his legacy.

THE LITTLE STREET – INTO VERMEER'S WORLD

However many times we see *The little street*, it still comes as a surprise that what looks so much like a photograph in reproduction can look so much like one in the museum, at least from ten paces away. The framing of the scene seems photographic, for we would never see it like this, with oddly cut-off walls and windows and gables, unless we were composing a rectangular picture through the lens of a camera. The cloud cover yields an even light, casting

faint shadows under the benches, the shutters and the foliage. Seen close up, Vermeer's just-perceptible brushstrokes and bits of scruffy pigment make us marvel that paint can represent bricks, mortar, woodwork, whitewash, mossy growth, drifting clouds, water trickling down the alley gutter so persuasively as to convince us that Vermeer gave us just the facts. Once we have noticed details such as the stained whitewash at the base of the wall between the two alley doorways we relish the other imperfections that render these houses quaint. Greyish-blue dabs laid over reddish-brown paint suggest patched cracks in the brickwork; gradients of beige and blue hint of peeling paint on shutters; quavering lines of grey and blue intimate old window leading. Any painting with this much real-life texture and descriptive detail risks losing compositional and spatial coherence, but *The little street* orders the anecdotal information by careful surface patterning and restrained perspective.

The painting's composition can be bisected precisely along the left wall of the house on the right. This is one of the few geometric principles about the scene that can be ascertained with ease, although the complex repetitions and mirrorings of rectangular windows, shutters, wall fragments, arches and triangular roofs and gables suggest patterns. Here we are constantly confounded: for all its apparent geometric system the painting offers only approximate symmetries and just-off alignments rather than mathematically predictable proportions. The single red shutter to the right of the open door, for example, is narrower than the two green ones on the other side, even though we would expect the windows to which they belong to be the same width. The windows are set at unequal distances from the door, which itself is placed off-centre in relation to the stepped gable and windows above it. Vermeer created a harmonious patterning of sharp contrasts (sky versus wall, shut versus open, black versus white), not-quite symmetries and near repetitions of shapes painted in a modulated palette of allied colours: white-to-ochre, black-to-grey, grey-to-blue, red-to-brown, beige-to-pink and greens. This interest in geometric rhythms in white, black, red and green was more conspicuous in the work of contemporaries such as Pieter de Hooch. His famous *Interior with women beside a linen chest* (fig. 2) offers an unexpectedly bright, partial view of a façade through the open door in the back wall. Here hard-edged rectangles, lines and semicircles announce an obvious delight in visual syncopation. In Vermeer's composition, the individual bricks, cement layers, windowpanes and leaves are not sharply defined as they are in De Hooch's contemporaneous works (fig. 3). Much as in life, our eyes register brick walls and dark windows encroached upon by foliage, not the detailed work of craft and nature.

The frontal aspect of the façade, with its shutters flush against the walls, is relieved only by glimpses down the

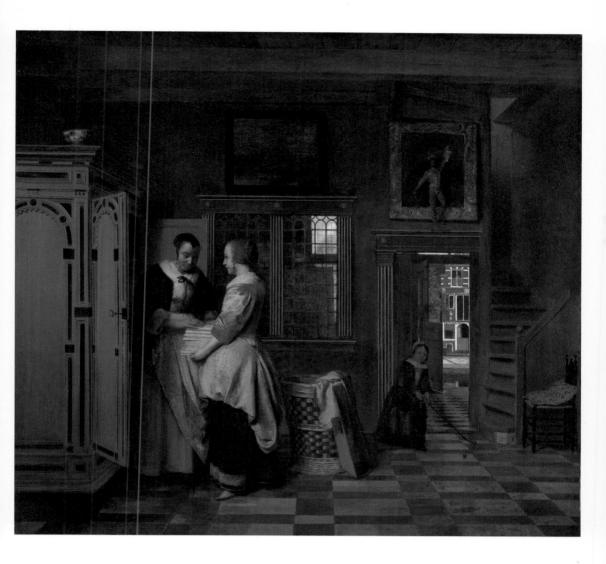

2
Pieter de Hooch, *Interior with women beside a linen chest*, 1663. Oil on canvas, 70 x 75.5 cm. Rijksmuseum, Amsterdam.

alley, into the entrance and above the connecting wall, set up by discreet markers of recession. The rows of cobblestones – indistinctly rendered as they would appear to viewers looking at the houses rather than at their feet – and the small gutter recede along lines that converge at a point to the upper right of the alley doorway, on the imaginary vertical that divides the composition in half. A minimum of elements

supports this perspective: the receding light brown wall and roof of the house on the left, just above the wall that connects the two facades, and the three narrow benches that jut out – presumably at right angles – from the whitewashed walls. Vermeer integrated these benches into the composition with such economy that they at first seem mere lozenges and rectangles of paint that contribute to the play of patterns.

3
Pieter de Hooch,
*Three women and a man in
a courtyard behind a house,*
c. 1657-59. Oil on canvas,
60 x 45.7 cm. Rijksmuseum,
Amsterdam.

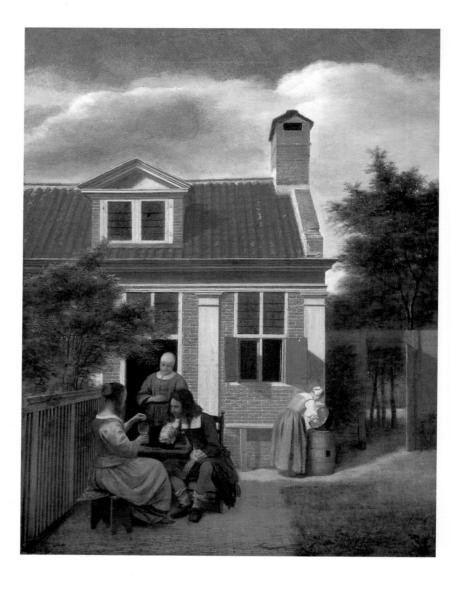

These dabs of colour are small feats of foreshortening, as unobtrusive as they are effective.

Perspective construction is not displayed here for its illusionist pleasures, as it so often was in the architectural paintings Vermeer must have seen in Delft. Gerard Houckgeest's *Interior of the Oude Kerk in Delft* (fig. 4) uses perspective to play with our powers of perception. It pretends to let the painting protrude into our space by suspending an illusionistic curtain in front of the picture surface from an equally imaginary curtain rod. At the same time, it gives us a deep, oblique view through the illusionistic frame into the church space, using repeated

columns and rapidly diminishing floor tiles to set up a dazzling perspective. Vermeer, in contrast, does not let us see far. The black of the interior beyond the woman sewing almost mirrors that of the closed door to the left, allowing no more than a glimpse of a grey table and floor. The maid working by a water barrel is hemmed in by the back wall of the courtyard, its bluish white bringing it forward visually to align it with the whitewash on the façade.

The little street's realist trickery was surely not the least of its pleasures to Vermeer's contemporaries, and it may be an even stronger source of fascination now that virtual reality is available with the click of a shutter or a mouse. The painting is not a mere exercise in realism, however. Vermeer's subordination of the accidents of time and place

4
Gerard Houckgeest, *Interior of the Oude Kerk in Delft*, 1654. Oil on panel, 49 x 41 cm. Rijksmuseum, Amsterdam.

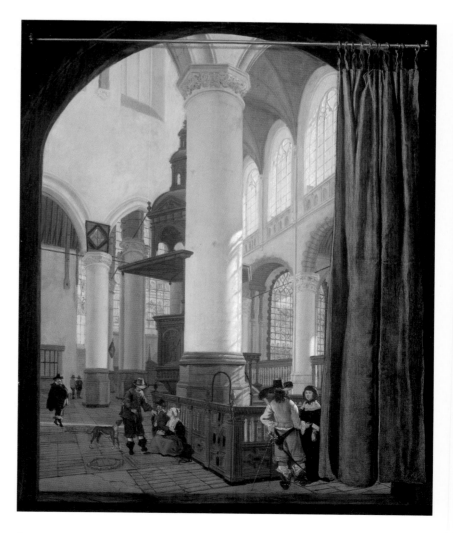

into a balanced but never rigid composition suggests a relationship between these old, robust buildings and the plain but orderly lives of the women and children in the scene. This moral connection has been substantiated recently by the confirmation of an old suggestion that Vermeer represented the actual façade of the Old Men's Home in Delft. The building in the right half of the painting formed part of this charitable institution, which provided accommodation for indigent men. In 1661, two years or so after *The little street* was painted, its second floor was rebuilt to create a new meeting hall for the Guild of St. Luke, the trade association of painters. If the façade of the resulting guildhall is superimposed on *The little street*, we can see that the bottom of the façade continued to match the bottom half of Vermeer's right hand building and alley (fig. 5). Having entered the guild in 1653, Vermeer must have known of the plans for conversion of part of the

5
Superimposition of reconstructed façade of St. Luke's Guildhall over Vermeer's *Little street*. Courtesy of Philip Steadman.

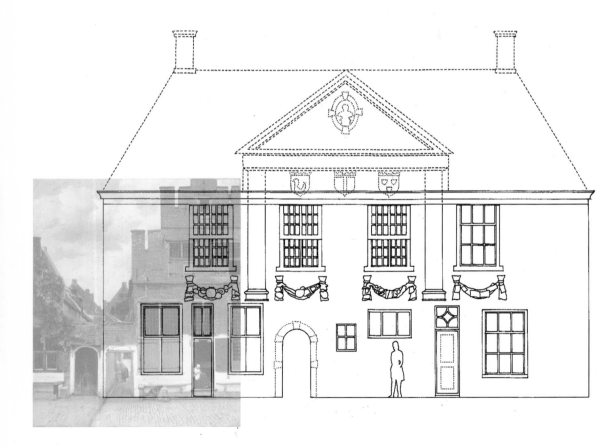

6
Pieter de Hooch, *The courtyard of a house in Delft*, 1658. Oil on canvas, 73.5 x 60 cm. National Gallery, London.

similarity and resemblance to their occupants) is evident enough from the simplicity of construction, … being without any show, ostentation or ornament to be seen on the outside, lying behind and between other houses, only giving on to a common street with a gate, yet each home with a roomy inner courtyard with small houses and rooms provided around it, so that the aged folk could each have a separate free dwelling and in their great age daily await the day of the Lord.'

Vermeer's *Little street* was not alone in using old-fashioned architecture to suggest virtue. De Hooch's *Courtyard of a house in Delft*, dated 1658, is close to Vermeer's painting in date, composition and affinity between a dwelling and its residents (fig. 6). The painting is almost a close-up and reversed version of Vermeer's view, looking out of a courtyard, through a passageway, on to the street. De Hooch's buildings are equally attractive in their cosy, slightly weathered and geometrically pleasing jumble of walls and openings, bricks and foliage. Like Vermeer, De Hooch gives us a privileged view of the domestic environment as the preserve of women and children. De Hooch's characters appear as unaware of our observing presence as Vermeer's figures.

The stone above the arch in De Hooch's painting is inscribed 'This is Saint Jerome's Vale, if you wish to retire to patience and meekness. For we must first descend if we wish to be raised. Anno 1614'. The tablet (still extant) must have come originally from the

Old Men's Home, and he may have decided to commemorate the earlier view of the building before he and his colleagues took it over.

The jumble of buildings that made up the Old Men's Home played a significant role in the civic imagination of Delft. In 1667, Dirck van Bleyswijck, the town chronicler, praised the home's architecture for the very qualities Vermeer's painting seems to promote: 'That these [Old Men's and Old Women's] homes are very old (and accordingly have proportionately great

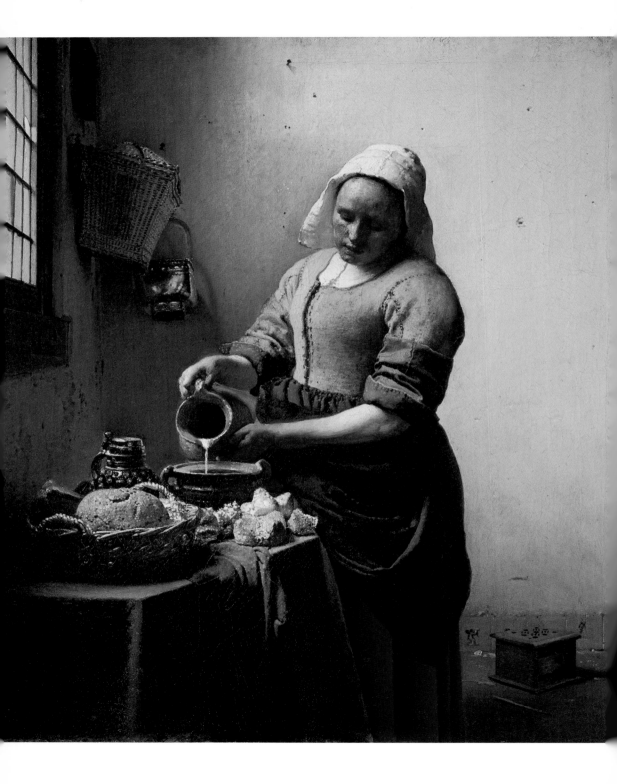

Hieronymite monastery, which had been a prominent religious foundation in Delft until most of it was destroyed by fire in 1536. Van Bleyswijck's history of Delft mentions the monastery's great reputation and impressive premises, and it notes that 'several excellent residences' now filled its plot. The house represented by De Hooch may be one of these, for Van Bleyswijck notes that these houses are connected to the street by 'two gates or corridors … the northern one of which has retained the name Hieronymus gate'. The stone in De Hooch's painting may have been saved and integrated into the façade of this gate – possibly, as De Hooch's inscription indicates, in 1614. Associated with the restorative functions of the buildings they inhabit, De Hooch's and Vermeer's residents gain in domestic virtue – or so these paintings seem to suggest.

Vermeer apparently did not repeat the intimate cityscape that is *The little street*. Although atypical of his themes, the painting introduces us to much of what characterizes Vermeer: his interest in rendering the world in a manner resembling optical reality, his grounding in the artistic and social soil of Delft, and his dedication to painting virtue. However diminutive, the four self-absorbed figures in *The little street* also announce Vermeer's concern with the representation of the private person in his, or more usually her, domestic setting.

THE KITCHEN MAID – THE PICTURE OF DOMESTIC VIRTUE

The simplicity of place and chores valued in *The little street* is writ large over the surface of Vermeer's *Kitchen maid*, painted about 1658-59 (fig. 7). Whereas the women and children of *The little street* lend human scale and virtuous tone to the dwellings that are the picture's main event, *The kitchen maid* subordinates plain interior architecture to her physical and moral weight. Unlike the supporting cast members in the earlier painting, the maid stands firmly centre stage, seen front on and from slightly below. Like them, she appears engrossed in her task, unconscious of our presence. With a stunning display of virtuosity, Vermeer convinces us that we are seeing a moment frozen in time: the slow but continuous trickle of creamy fresh milk from the earthenware pitcher into the bowl.

Vermeer took remarkable care in designing this view of a woman dedicated to her chore. There are riveting bits of information about the past life of the architecture: pits and stains in the whitewash, two nails in the wall that may have held pictures or mirrors, a small break in a window-pane that allows daylight to brighten a patch of window frame. But all this detail is unobtrusive compared to the imposing maid and the well-lit group of utensils and foodstuffs, finely differentiated in texture. A still life in circles and ovals, the jugs and rolls are extensions in shape of the amply curved maid. In

8
Vermeer's *Kitchen maid*,
with pinprick indentation
at vanishing point circled
and with several orthogonals
superimposed.

western representation from Van Eyck to Rubens, such well-roundedness had long signified the female capacity for nurture. The maid and her paraphernalia form a wedge of domestic preoccupation covering a third of the picture surface. Her bulk is enhanced by the sharp light-dark contrast along her left side (right from our point of view), which Vermeer reinforced with a line of bright white paint. Before silhouetting her in this way, Vermeer had already removed a distracting wall map or painting from behind her head, as close scrutiny reveals (fig. 7).

X-ray images show how Vermeer constructed the perspective of the interior. A small pin-sized hole above the

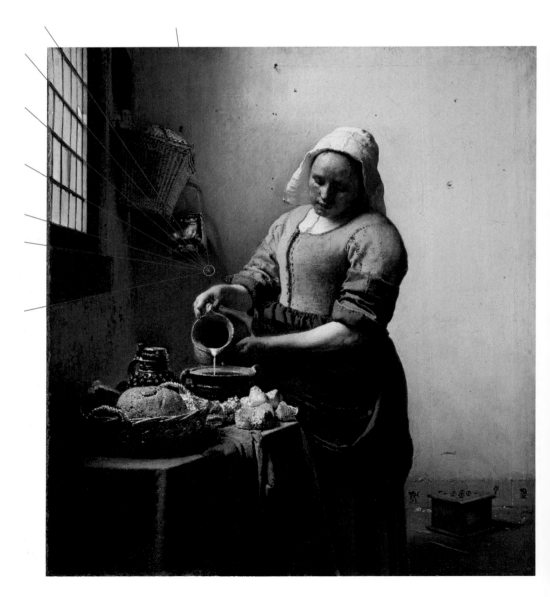

maid's right hand (circled in fig. 8) co-incides with the vanishing point: the imaginary point at which most of the lines receding into the space appear to converge. These orthogonals, as they are called, are obvious along the windowsill, the lead strips that divide the window-panes, and the side of the basket hanging on the wall (fig. 8).

To set up a perspective construction, 17th-century painters often used the so-called pin-and-string method, an artisan's substitute for a detailed preparatory drawing of a composition's perspective geometry. The artist would choose a vanishing point on the painting's imaginary horizon line, push a nail into that point on the canvas or wood panel, and tie a string to the nail. After dusting the string with powdered chalk or charcoal, the painter would pull the string taut and let it snap on to the painting's preparatory surface to create lines that would indicate the position of the orthogonals.

Vanishing-point pinholes can still be discerned in 13 of Vermeer's 34 surviving paintings.

Vermeer constructed his perspective to suit his thematic needs. The vanishing point in *The kitchen maid* is low compared to that in most of his paintings. This positioning places the imaginary viewer below the maid, making her loom slightly over us. The receding side of the table does not follow the dominant perspective construction, however, for if it served as an orthogonal it would end up to the right of the maid and possibly outside the painting's frame. Some have tried to argue that this is because the tabletop had a pentagonal outline that caused Vermeer trouble. The 'real' shape of the tabletop is surely irrelevant, though, for the table's refusal to obey the perspective scheme must have been Vermeer's choice, meant to enhance our focus on the maid and her responsibilities. The near-frontal alignment of the table keeps the maid close and in the centre, and it reduces the emphasis on one-point perspective as a goal in itself. The slightly inconsistent upward tilt of the table also allowed Vermeer to detail the ceramics and the bread in great variety. The materiality of these objects is much enhanced by the rough, sand-like additives Vermeer mixed with the paint; elsewhere, the paint surface is much smoother.

The kitchen maid's act of pouring milk is certainly meant to suggest her nurturing role, her pose intended to embody conscientiousness. Her serious dedication to a humdrum

9
Jan Rinke, *Minister P. Rink and the kitchen maid from the Six collection*, cartoon on American interest in Vermeer's *Kitchen maid*, from *Het Vaderland*, 9 November 1907. Caption: 'With the money Sam gains from Holland on the Exchange, he curries favor with Holland's fairest milkmaid.'

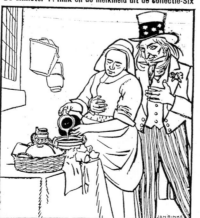

De Minister P. Rink en de melkmeid uit de collectie-Six

Raakt Holland op de beurs aan Sam zijn goeie geld kwijt,
Hij dingt er met, brutaal, naar Hollands knapste melkmeid

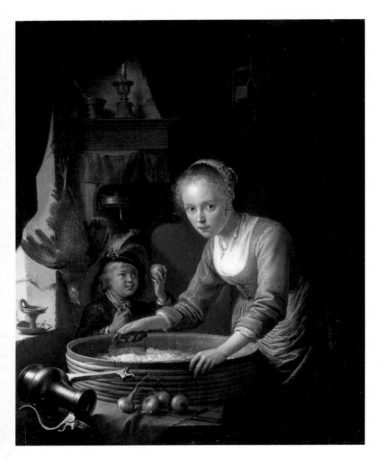

10
Gerard Dou, *Girl chopping onions*, 1646. Oil on canvas, 18 x 14.8 cm. The Royal Collection, Her Majesty Queen Elizabeth II.

Dutchness and to Vermeer. When the sculptor W.T. Schippers was commissioned to make a monument on the occasion of the 300th anniversary of Vermeer's death in 1975, he cast a rough-hewn version of the maid in concrete. And yet the harder we look for precedents or parallels to Vermeer's kitchen maid, the less conventional her virtue looks. Indeed, she may owe her exalted position in the history of Dutch art to her very novelty and inimitability: once Vermeer had got this dream of the domestic servant right, few artists attempted to replicate his conception.

Women at chores did not constitute a new genre when Vermeer came to it – 15th- and 16th-century Netherlandish painting is full of domestic activity inspired by Biblical narrative, from sewing and spinning to spoon-feeding and washing up, most of it rendered with high fidelity to the textures and rituals of everyday life. Nevertheless, in Vermeer's time a more exclusive focus on maids was gaining currency. Compared with most of the painted maidservants of the period, Vermeer's is conspicuously immune to distraction. Most are seen in the company of their ladies, sometimes labouring diligently but often caught asleep (in Nicolaes Maes's series of paintings on this theme) or meddling in their mistresses' affairs (in the intimate scenes of Gerard ter Borch or the rowdy ones of Jan Steen). Gerard Dou's maidens preparing food, to which Vermeer's maid is often compared, eye the viewer seductively (fig. 10). It is difficult to

task accounts for much of the picture's status as the canonical image of Dutch domestic virtue. In 1907, when the Six van Vromade family decided to sell the painting, the government's tortuous but successful attempts to acquire 'Holland's fairest milkmaid' became a matter of keen public debate. Cartoonists portrayed her as staunchly ignoring the lascivious advances of Uncle Sam, an allusion to an American collector presumed ready to pounce on the painting (fig. 9). Modern artists have frequently taken Vermeer's maid as inspiration for homages to solid

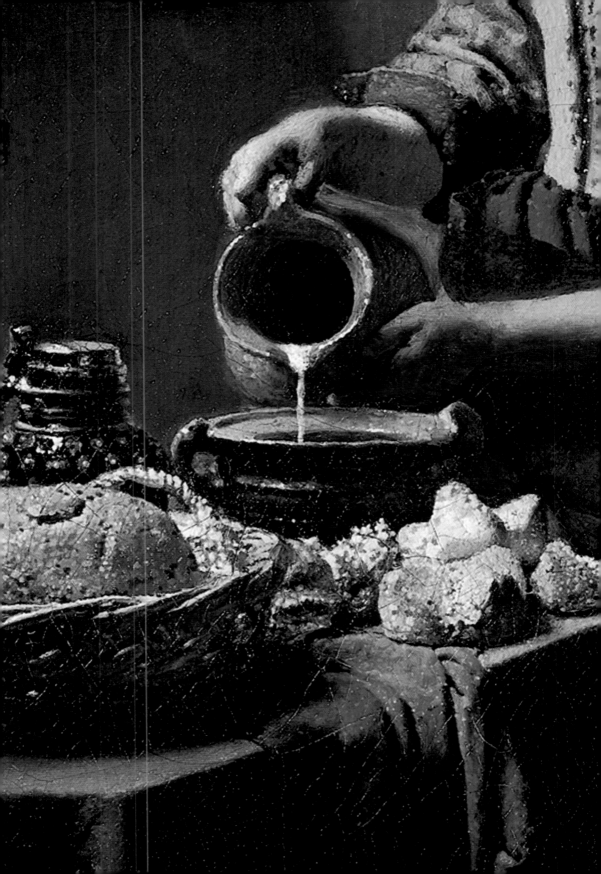

11
Johannes Vermeer,
A maid asleep, c. 1656-57.
Oil on canvas, 87.6 x 76.5 cm.
The Metropolitan Museum
of Art, New York.

imagine Vermeer's maid interrupting her action for the viewer's gratification. Milk does not figure prominently in the Dutch repertoire of domestic chores, and when it does it usually comes from a maternal breast. Although *The kitchen maid*'s seriousness separates her from her pictorial peers, Vermeer was clearly aware of them. His very first painting of a young woman alone in a room, the more elegantly attired *Maid asleep* of c. 1657 (fig. 11), had melded an older pictorial tradition of high-life ladies in a drunken stupor with Maes's clever

paintings of dozing maids. The cause of the woman's unconsciousness seems clear, for a wine jug in Delft white and an overturned wineglass press up to our space, but Vermeer applied himself to understate the obvious. X-ray images of *A maid asleep* show that he painted out a dog in the open doorway and a man's head in the room beyond, thus eliminating two details that would have implied a scene of seduction. Contemporary painters of social life, Steen and Gabriel Metsu foremost among them, relished such over-determined storytelling for its comic or moralizing effects. Steen's *Merry family* (fig. 12) offers a characteristic example of this tendency, taking as its theme an old Dutch proverb about parental example, 'As the old sing, so pipe the young'. All the figures in the painting appear to act out the proverb, for we see children and youths 'piping' after their singing elders in every imaginable way – smoking, playing pipe instruments such as bagpipes and flutes, and drinking wine from a *pijpkan*, a pipe pitcher. Just in case the viewer might miss these references to the saying, its initial words are inscribed on the paper attached to the mantelpiece. Vermeer's refusal to tell such obvious tales even at a formative stage of his career tells us something of his wilful artistic independence.

As if to signal a developmental connection between the sleeping young woman and the attentive milkmaid, Vermeer provided *The kitchen maid* with a few hints of the ambiguous reputation of her kind in the Dutch

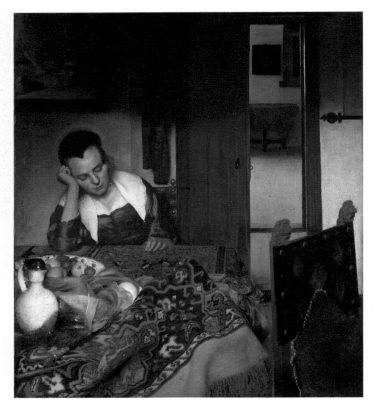

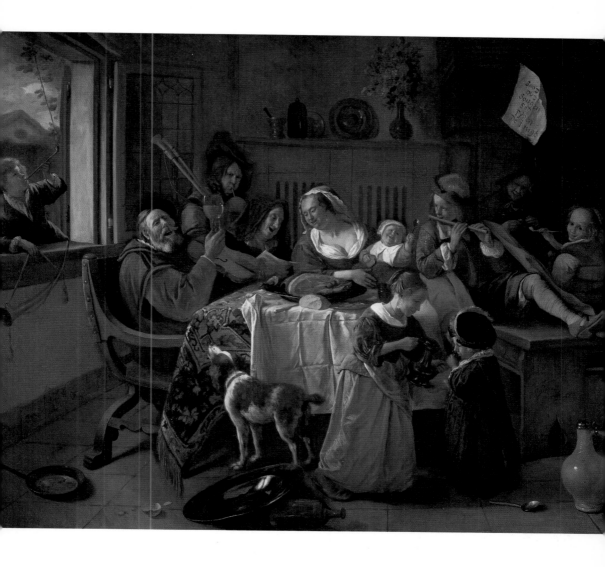

12
Jan Steen, *The merry family*,
1668. Oil on canvas,
110.5 x 141 cm. Rijks-
museum, Amsterdam.

bourgeois imagination. The sexual
preoccupations of female servants were
a delicious, forbidden fruit, turning up
irrepressibly in coarse farces as well
as subtle paintings. Vermeer inserted
restrained references to this stereotype.
The few tiles along the wall sport
images of Cupid, as Delft tiles often
did. More obviously to contempo-

raries, the wooden foot-stove was
a commonly understood emblem of
feminine lasciviousness. Vermeer's
choice of this prop was quite deliber-
ate, for infrared reflectograms, which
offer another way of looking below
the surface of a painting, show that
he painted it over a laundry basket
he had originally placed in this spot.

13
Geertruyd Roghman,
A woman cleaning, c. 1650-55.
Engraving, 224 x 178 mm.
Rijksmuseum, Amsterdam.

joked about as 'the darling of ladies'.
In paintings, it was often included
primarily to make this point, but if
anything, Vermeer's maid has for now
turned her back on her darling.
In tone and setting, Vermeer's *Kitchen
maid* may acknowledge a few images
of domestics above moral reproach
that had been made very shortly
before he painted his work. Geertruyd
Roghman's series of five engravings of
women at household tasks, made a few
years before her death in 1657, includes
several servants preparing food or
cleaning pots (fig. 13). All studiously
avoid our gaze. Even closer in manner
of presentation to Vermeer is Maes's
Woman plucking a duck, alone in her
lucid domain (fig. 14). In Vermeer's

As an effective personal warming
system that held glowing embers under
a woman's skirts, the foot-stove was

14
Nicolaes Maes, *Woman
plucking a duck*, c. 1655-56.
Oil on canvas, 58 x 66 cm.
Philadelphia Museum of
Art, Philadelphia.

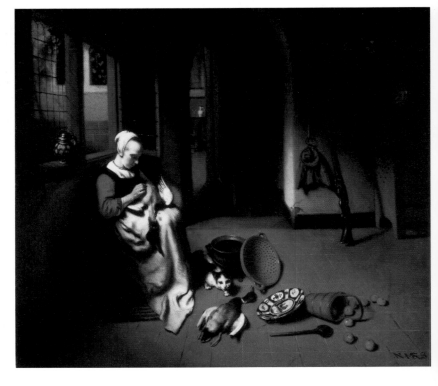

15
Nicolaes Maes,
*Girl at a window, known as
'The daydreamer'*, c. 1655.
Oil on canvas, 123 x 96 cm.
Rijksmuseum, Amsterdam.

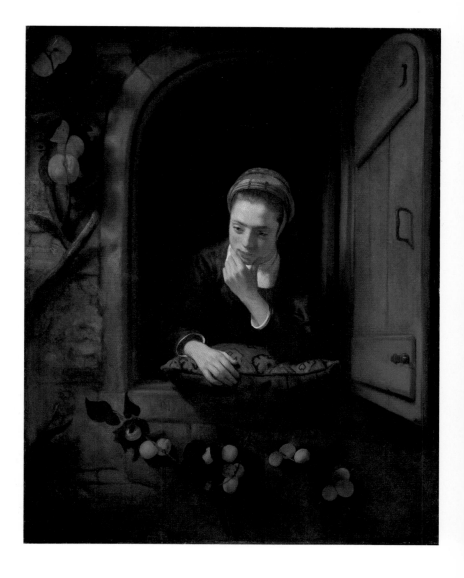

insistently realist vision, the sort of still life of earthenware dishes that Maes scattered on the floor is transformed into a plausible table arrangement. Seemingly as imperturbable as the kitchen maid, Maes's woman is at risk of moral subversion, for a distant wine glass and jug and discarded hunter's gear recall male presence. In her thoughtful dominance of the composition, Vermeer's maid more closely resembles Maes's *Daydreamer* (fig. 15) of the same time. Modestly dressed in the manner of a domestic servant, Maes's young woman rests her chin in her hand. Like so many of the figures by his teacher, Rembrandt, she focuses on her own thoughts rather than

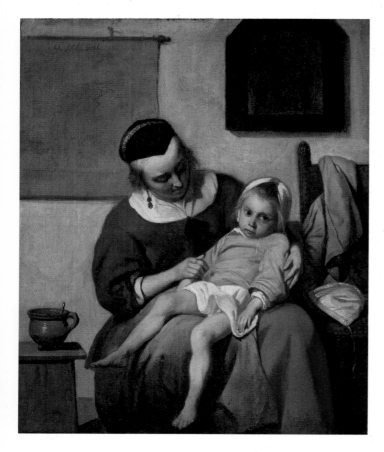

16
Gabriël Metsu,
The sick child, c. 1665.
Oil on canvas, 32.2 x 27.2 cm.
Rijksmuseum, Amsterdam.

of the upper echelons of the Dutch middle class. In self-conscious contrast to older aristocratic models of a proper, honourable life, large segments of the Dutch citizen elite and their religious leaders now championed domestic, familial virtue as much as public, commercial or martial achievement, and humble, private merits as much as political heroism. Vermeer's dedication to painting the everyday, the domestic and the humbly virtuous went hand in hand with a dedicated effort to find a realist style for this essentially bourgeois mentality. In the present historical moment these middle-class values have been in the ascendant for so long that they seem almost self-evident, as do the dazzling realist imaging techniques that represent them to us. It is in part for this reason that we value so highly Vermeer's apparent simplicity and 'photographic' techniques. In the 1650s, rendering or critiquing bourgeois domesticity in compellingly 'real' terms was rapidly becoming a true project for some of the most successful Dutch artists. Dou, Steen, Metsu, Maes and De Hooch virtually dedicated themselves to this task, some in innovative terms undoubtedly influenced by Vermeer. Metsu's *Sick child* of c. 1665 (fig. 16), for example, is an unprecedented painting of a child disoriented by illness, cared for by a woman whose undivided attention matches that of Vermeer's servants. The figures' careful silhouetting against a cool white wall probably acknowledges Metsu's source as well. Vermeer's understated rhetoric of the

a mundane chore. Whatever echoes of contemporary representations of female servants may reverberate off Vermeer's canvas, his kitchen maid trumps her closest peers in the novel combination of bold physical presence and rapt concentration.

So different in the way they place the viewer, *The little street* and *The kitchen maid* are both products of Vermeer's decision, early in his career, to paint the private practices, ideas and ideals

everyday and the interior thus partic-
ipated in a larger phenomenon. Some
of the factors that stimulated Ver-
meer's development of this pictorial
mode may be found in the mid-century
culture of Delft, which we will now
survey before returning to his two
later paintings in the Rijksmuseum.

VERMEER'S DELFT –
PATRIMONY AND PATRONAGE

Caravaggesque beginnings

The vital statistics of Vermeer's life
are known, and except for speculation
about the city of his training they
place him squarely in Delft. Vermeer
was born in 1632. He was the second
child of Reynier Jansz, also known as
Vermeer, and Digna Baltens, who had
him baptized in the Reformed Nieuwe
Kerk. Jansz prospered through a com-
bination of commercial activities. His
primary trade was satin weaving, but
he also rented an inn on the Volders-
gracht, the canal represented in *The
little street*. There, he apparently ran an
art dealership for he was registered in
the Guild of Saint Luke as a dealer
rather than a painter. In 1641 Jansz's
flourishing business enabled him to
buy a larger inn in Delft's central
square. After his father's death in
1652, Vermeer took over the inn and
the business.

Through his father's involvement in
the art world, Vermeer must have
become intimately familiar with the
artistic culture of Delft. Although his
teacher is unknown, it is most likely
that Vermeer was trained there. Since

he entered the guild as a master painter
in December 1653, at the age of twen-
ty-one, his training probably began
no later than 1650. In the year of his
guild acceptance he married Catharina
Bolnes, the daughter of Maria Thins.
Vermeer converted to Catholicism
before the wedding, almost certainly
at Thins's request, but apparently
with commitment. His marriage to
Catharina produced at least 11 chil-
dren, and his work and family kept
him in Delft until his death in 1675.
Vermeer's finances were not in good
order when he died. His diminished
circumstances may have been the result
of a slump in the art market in 1672,
the national 'year of disaster' when the
Dutch Republic faced French invasion
and battles with English and German
armies. Many artists suffered losses
that year.

Vermeer and his bride probably met
through artistic channels. Thins was
distantly related to Abraham Bloemaert,
a painter of Utrecht, and she had a
small but distinguished collection of
paintings from that city. Bloemaert
painted in an Italianate style and men-
tored several painters who, unlike him,
had travelled to Italy. These younger
painters brought back the innovations
of Caravaggio and his followers, and
in the 1620s created a veritable Utrecht
school of Caravaggesque painting.
Bold figures seen close up, nocturnal
settings with strong chiaroscuro, and
historical themes and scenes of rakes
and prostitutes were hallmarks of the
Caravaggesque mode. Thins owned
such paintings, including Dirck van

17
Dirck van Baburen,
The procuress, 1622. Oil on
canvas, 101.6 x 107.6 cm.
Museum of Fine Arts, Boston.

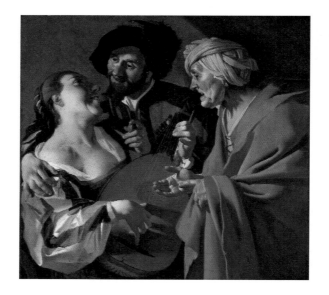

18
Johannes Vermeer, *The concert*,
c. 1665-66. Oil on canvas,
72.5 x 64.7 cm. Isabella Stewart
Gardner Museum, Boston
(stolen March 1990).

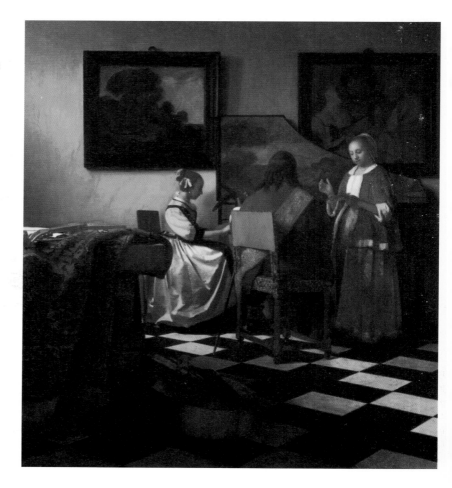

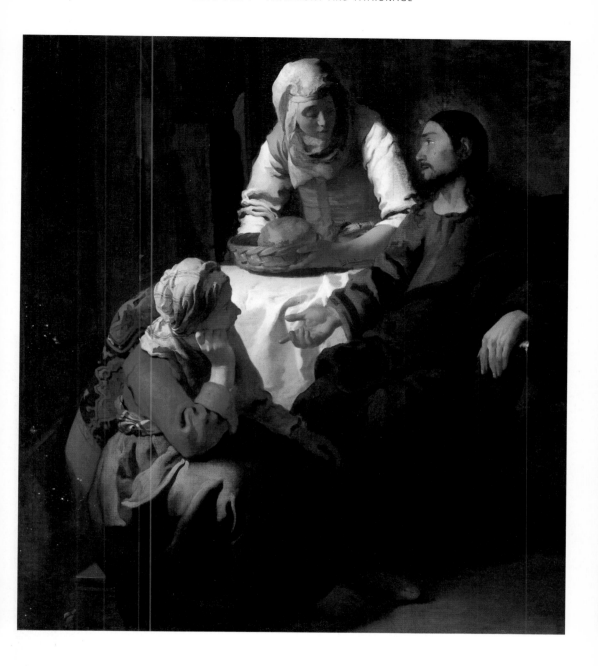

19
Johannes Vermeer, *Christ in the house of Martha and Mary*, c. 1654-55. Oil on canvas, 158.5 x 141.5 cm. The National Gallery of Scotland, Edinburgh.

Baburen's *Procuress* (fig. 17). Vermeer incorporated this picture in at least two works from his mature career (fig. 18). His knowledge of his mother-in-law's collection may in part account for the look of his earliest paintings, which postdate his 1653 wedding and guild membership.

Christ in the house of Martha and Mary (fig. 19), probably painted about 1655, is closest in tight composition, shallow space, warm colouring and conspicu-

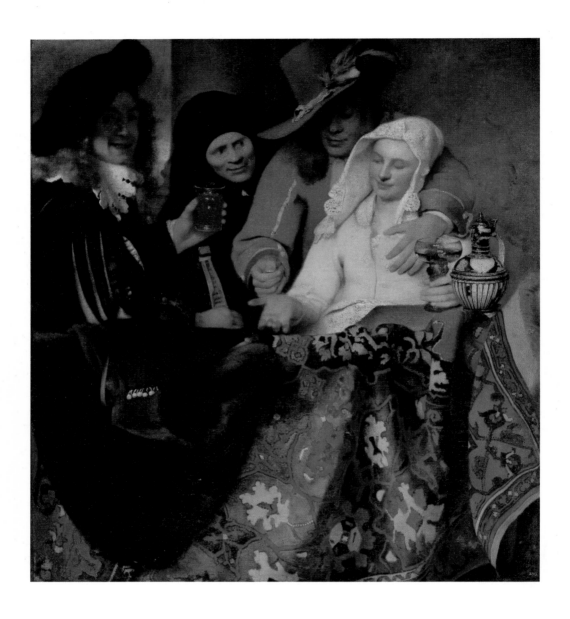

20
Johannes Vermeer,
The procuress, 1656.
Oil on canvas, 143 x 130 cm.
Staatliche Kunstsammlungen,
Gemäldegalerie Alte Meister,
Dresden.

ous, flowing facture to the style of Utrecht painters such as Van Baburen and Hendrick Terbrugghen. Only the well-rounded figures, economical gestures and light-dark contrasts that shape Martha's face and arm make this painting a stylistic forebear of *The kitchen maid*.

Vermeer's *Procuress*, signed and dated 1656, updates pictures like Van Baburen's (figs. 20, 17). Smoother in finish and newly stocked with realist

detail (particularly in the carpet, glass-ware and stoneware jug), the painting nevertheless experiments with the Caravaggesque penchant for pressing figures close together and up to the picture plane, in airless configurations suggestive of the brothel's steamy intimacy.

These paintings bear little resemblance to the Vermeer we now cherish for his optical observation and his renderings of the new bourgeois world, even if the themes they deal with – a domestic New Testament narrative and, in *The procuress*, the subversive opposite of middle-class virtue – were to remain central. Had he continued to paint in this vein he might be remembered today as a somewhat old-fashioned minor master. The Utrecht tenor of these works has led art historians to speculate that Vermeer may have trained in that city, but given the time lag between his attainment

of master's status and the production of these works there is no need for this hypothesis. His art dealer's eyes and close acquaintance with Thins's collection surely offered sufficient spur to try out the Caravaggesque mode. Such a market motivation is suggested by the 1657 inventory of an art dealer in Amsterdam, which lists an undoubtedly similar history painting by Vermeer.

To understand how Vermeer made the leap from the claustrophobic composi-tions and shallow spaces of these early pictures to the lucid and airy spatial constructions of *The kitchen maid* and *The little street*, we have to look at his colleagues in Delft. As a dealer and active guild member (he was elected as an officer of the guild in 1662-63 and 1670-71), Vermeer learned more from his contemporaries in Delft than from his artistic predecessors in Utrecht. The town offered a stimu-lating culture for a youth of artistic inclinations.

William of Orange and the artistic culture of Delft

In the 1650s Delft had all the strengths of the great cities of Holland (fig. 21). Like Leiden and Haarlem, the most comparable Dutch towns, Delft enjoyed the fruits of recent population growth, efficient connections to other cities by water and land, and a solid eco-nomic base in beer brewing, tapestry weaving and the Delft ceramic indus-try. Delft, however, stood out because of its august role in the history of the Dutch revolt against Spanish rule.

21
Johannes de Ram and Coenraet Decker, *Figurative map of Delft*, 1st ed. 1678, this ed. 1703 or 1752. Engraving and etching, 1098 x 1260 mm. Stedelijk Museum Het Prinsenhof, Delft.

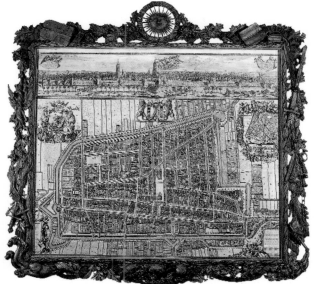

22
Gerard Houckgeest, *Interior of
the Nieuwe Kerk in Delft with the
tomb of William the Silent*, 1650.
Oil on panel, 125.7 x 89 cm.
Hamburger Kunsthalle,
Hamburg.

In 1572 William of Orange (1533-84),
the reluctant leader of the rebellion
and first stadholder of the Dutch
Republic, chose the well-fortified city
as his seat. A political adversary assas-
sinated him there in 1584, prompting
the States General to commission a
monumental tomb in Delft's Nieuwe
Kerk (fig. 22). When the young Repub-
lic and the House of Orange set up
their headquarters in The Hague, not
far away, the town retained strong ties
to the government and the descendants
of William of Orange, who became the
Republic's chief military officials and
power brokers. Delft's twin loyalties to
the house of Orange and the States
General had a direct effect on local
artistic culture.

Around the middle of the century,
the spectacular tomb of William of
Orange became a thematic preoccu-
pation for a brilliant group of architec-
tural painters active in Delft. In 1650,
Gerard Houckgeest and Emanuel de
Witte began to paint an ambitious
series of perspective views of the tomb
in its setting. A large and finely exe-
cuted panel painting by Houckgeest
may have been a commission from an
Orange-minded loyalist, a local cham-
pion of Delft's history or even the
States General (fig. 22). Houckgeest's
lead was followed by several artists,
who continued to paint the theme in
an infinite variety of compositions.
The monument in the Nieuwe Kerk
provided artistic ferment for the
development of a kind of painting
that combined ambitious perspective
drawing with a virtuoso imitation of
textures and smooth surface finish.
In the years just after 1655, when
Vermeer was becoming the Vermeer
of *The little street* and *The kitchen maid*,
the realist effects of architectural
painting in Delft must have looked
irresistible.

Delft's loyalty to the States General
had a more dramatic impact on the city.
The States General had for years kept
a large arsenal within the city walls.

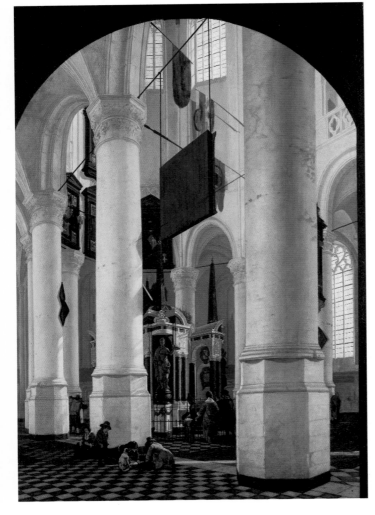

23
Carel Fabritius,
Abraham de Potter, 1640.
Oil on canvas, 68.5 x 57 cm.
Rijksmuseum, Amsterdam.

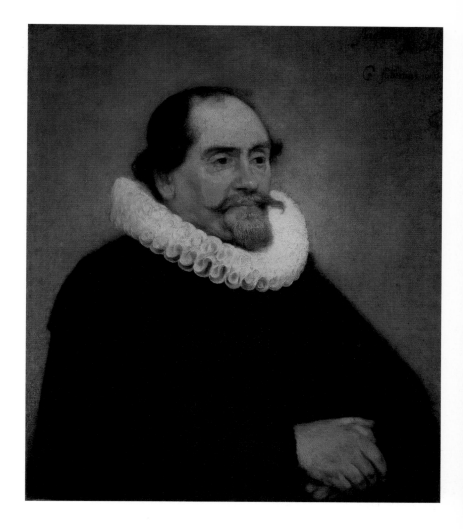

On the morning of 12 October, 1654, a massive explosion in one of the gunpowder stores devastated city blocks, ripping open houses and erasing the outlines of streets. The city historian Van Bleyswijck estimated the death toll at between 500 and 1000 – staggering for a town of 25,000 inhabitants. Most famous among the dead was the painter Carel Fabritius, still young at 32 and only recently arrived from Rembrandt's studio, where he had learned to paint history paintings and portraits in his master's manner (fig. 23). Decades after the disaster, Fabritius's death occasioned Arnold Bon to publish a eulogy in Van Bleyswijck's history of Delft (1680 edition). Its last four lines offer the only contemporary statement of Vermeer's artistic parentage: 'Thus did this Phoenix, to our loss, expire / In the midst and at the height of his career / But happily there arose from his fire / VERMEER, who masterfully trod his path'

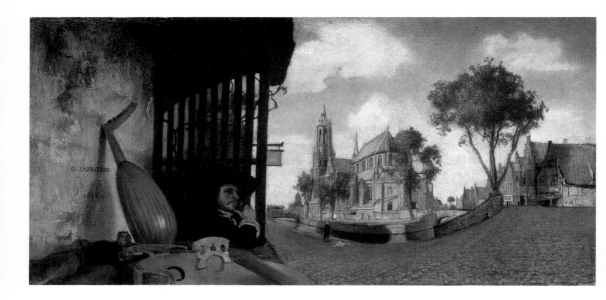

24
Carel Fabritius,
View of Delft, 1652.
Oil on canvas, 15.5 x 31.7 cm.
National Gallery, London.

25
Carel Fabritius,
The goldfinch, 1654.
Oil on panel, 33.5 x 22.8 cm.
Royal Cabinet of Paintings
Mauritshuis, The Hague.

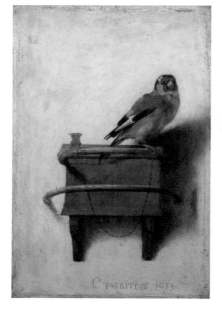

Written soon after Vermeer's own death in 1675, Bon's lines were the product of hindsight, but the genealogical claim makes visual sense. This was probably not a matter of artistic training, and hardly one of similar themes. Of Fabritius's dozen or so surviving paintings, half originated in Rembrandt's ambit (and look the part) and the others were painted in Delft. Of those, only the small *View of Delft* has a thematic echo in Vermeer's grand view of the city (figs. 24, 27). Vermeer's close knowledge of Fabritius's work is suggested more powerfully by a similar way of seeing and by a shared interest in experimentation with optical effects. *The goldfinch* (fig. 25) invites us to linger over the sorts of details that enliven *The little street*: the colouristic nuances in the whitewash and shadows, the irregular reflections off the chain, the slight asymmetries in the perch. Fabritius gave the small bird real presence without sharply delineating each feather or each smudge on the plaster, and without evening out the surface in the smooth manner of contemporaries such as Houckgeest or Dou.

30

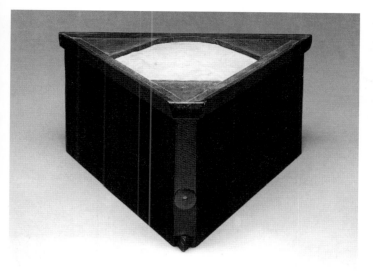

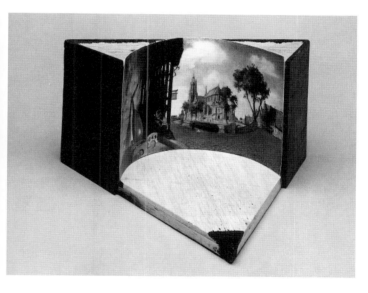

26
Reconstruction of the perspective box that may have been original display device for Fabritius's *View of Delft*. Courtesy of Walter Liedtke.

pupil' Fabritius (they had been in Rembrandt's studio together). 17th-century inventories list (perspective?) boxes and optical illusions by Fabritius. His oddly distorted *View of Delft,* for instance, must have been mounted curved into a perspective box (fig. 26). Seen through the peephole, the scene of the Nieuwe Kerk would dominate, and the enlarged musical instruments would be scaled down. The lack of interest in perspective or optical realism in Vermeer's earliest paintings makes it unlikely that he studied with Fabritius (figs. 19, 20). His concern with that kind of painting arose some time after Fabritius's death, perhaps in partial acknowledgment of the loss of so stimulating a colleague.

Vermeer and the connoisseurs
The innovative work produced in the early 1650s by Houckgeest and Fabritius appears to have been attractive to collectors and perhaps to patrons who commissioned directly from local artists. A few of Vermeer's customers are known by name, profession and art collection, and they belonged to Delft's citizen elite. Vermeer apparently enjoyed the almost exclusive patronage of Pieter Claesz van Ruijven (1624-74), a collector who owed his fabulous wealth to a brewing inheritance and shrewd investments. Most of the 20 Vermeers owned by Van Ruijven can still be identified today. This statistically unlikely fact, combined with the knowledge that several Vermeers in early references to his works are also still known, suggests

Vermeer's thoughtful use of perspective to structure the viewer's experience probably owed much to Fabritius's experiments as well. Van Bleyswijck called Fabritius 'quick and sure in matters of perspective', and in 1678 Samuel van Hoogstraten, a great perspectivist himself, mentioned the illusionist murals of his 'fellow

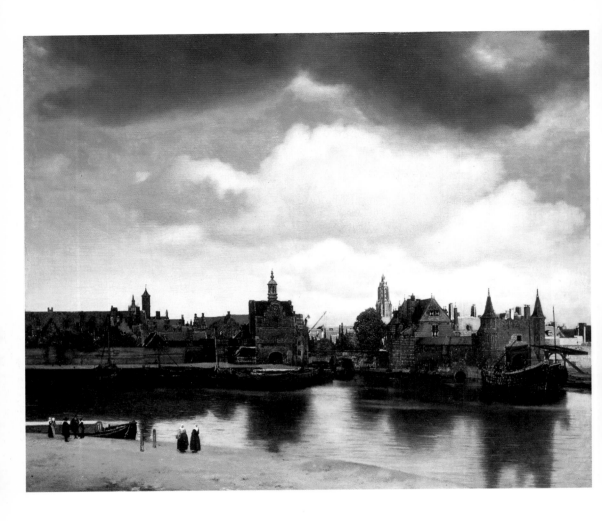

27
Johannes Vermeer,
View of Delft, c. 1660.
Oil on canvas, 98.5 x 117.5 cm.
Royal Cabinet of Paintings
Mauritshuis, The Hague.

that his small surviving oeuvre is a substantial part of his original output. In his 22-year career as a painter, Vermeer may not have painted more than about 50 works. Most 17th-century painters would not have been able to survive on such a small volume of work, let alone support 11 children. And yet that slow record of production corresponds to our sense, confirmed time and again by technical studies, that Vermeer worked in a most delib-erate, painstaking fashion, probably letting time pass before returning to a work. It is likely that Van Ruijven supported Vermeer's experimental working process by keeping him on a retainer. In the 1630s and 1640s, a cousin of Van Ruijven had paid Gerard Dou 500 guilders a year for the right of first refusal on the painter's new works. The example may have prompted Van Ruijven to reach a similar agreement with Vermeer.

The 20 works Van Ruijven bought from Vermeer range in date from about 1657 to the early 1670s, including the Rijksmuseum's *Little street* and *Kitchen maid,* the *View of Delft* (fig. 27) and probably the late *Young woman standing at a virginal* (fig. 28). The chronological spread of these works indicates the longevity of the arrangement between patron and painter, and suggests that it may have gone beyond a mere business transaction to conversations about artistic issues. It is striking that the earliest known contact between Van Ruijven and Vermeer, a loan or advance of 200 guilders in 1657, coincides with the painter's abandonment of the Caravaggesque mode and his new pursuit of domestic themes and optical verisimilitude. The personal interest Van Ruijven and his wife took in the painter is suggested by a highly unusual bequest in the couple's will of 1665 – Vermeer was to receive 500 guilders after the deaths of both marital partners. The gesture may have been made to ease his transition from life with an annual retainer to complete market autonomy.

Van Ruijven must also have offered Vermeer entry into the world of discerning connoisseurs and powerful functionaries at the highest end of the art scene. The paragon of such sophistication was Constantijn Huygens, the intellectual secretary to the stadholders. Huygens wrote knowledgeably about the Netherlandish art of his time, and acted as a scout for The Hague circles, brokering Rembrandt's early success at the court. No direct contact between Huygens and Vermeer is attested, and yet it is inconceivable that he would not have known of the nearby painter and his patron. Huygens's son Constantijn Jr was friendly with Diego Duarte, a fabulously wealthy banker in Antwerp who owned a painting by Vermeer of a woman playing the virginal (possibly fig. 28).

Two acquaintances of Huygens Sr travelled to Delft to seek out Vermeer, possibly on Huygens's recommendation. In 1663, the French diplomat Balthasar de Monconys admired the tomb of William of Orange and returned to Delft a week later just to see Vermeer. The visit was not a success: Vermeer was unable to show his guest a single work. De Monconys eventually saw one painting, at a baker's, and he found the single-figured work excessively priced at 600 guilders – a good indication of Vermeer's high market value. Pieter Teding van Berckhout, a patrician with familial connections to the Huygens family, had better luck. After travelling to Delft with Huygens in 1669, he recorded his visit to 'an excellent painter named Vermeer'. Van Berckhout, who may have been accompanied by Huygens on the studio visit, was shown several 'curiositez'. These impressed him sufficiently to warrant a second call on the 'celebrated painter named Vermeer', during which he saw several more paintings whose 'most extraordinary and most curious part is in the perspective'.

28
Johannes Vermeer, *Young woman standing at a virginal*, c. 1670-72. Oil on canvas, 51.7 x 45.2 cm. National Gallery, London.

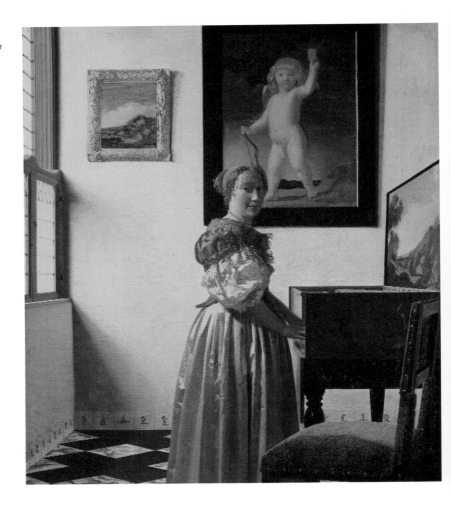

What emerges from these glimpses of the great and the good courting Vermeer is a culture in which access to the latest artistic knowledge depended on personal introductions. Even in the Dutch Republic, where painters sold their works through diverse public channels, some of the most innovative art remained primarily accessible through private brokerage.

Teding van Berckhout's term 'curiositez' for Vermeer's paintings is revealing, for it evokes the world of the cabinet of curiosities, pre-modern private and elite museums in which objects of natural history and art were shown in meaningful interaction. In Vermeer's time, the curious work of art still preserved the flavour of aristocratic origin.

34

Perspectives

How we would like to know just which paintings Van Berckhout described as extraordinary in their 'perspective'! By 1669 the term had a long history and wide range of meanings, and except for Vermeer's early history paintings or late close-ups most of his works qualify for the classification. In 17th-century Dutch, the French *perspective* and Italian *prospettiva* were usually translated as *doorsien* ('through-view'), and that term applied especially to the deep spaces constructed in perspective boxes (figs. 24, 26) and to interior views through several doorways (fig. 6). No perspective box by Vermeer is known, but a few Vermeers in early collections were referred to as being in a box. Vermeer's most ambitious view-through paintings – *The art of painting* and the Rijksmuseum's *Love letter* (figs. 49, 42) – may well have been among the works Van Berckhout saw, given that they can plausibly be dated to the late 1660s and were not bought by Van Ruijven.

There was one other form of perspective at which Vermeer excelled, even though he may have practised it only once. The Renaissance invention of perspective drawing was intimately linked to cityscape and to panoramic stage sets. The *View of Delft*, painted 1660-61, was described as such a perspective in a sale catalogue of 1696, and it is at once imposing, convincing and inviting (fig. 27). The painting proclaims Vermeer's inseparable links to the culture of Delft. It is an arresting monument to the city and its his-

torical role, signalled subtly by the sunlit aspect of the tower of the Nieuwe Kerk. No Delft contemporary would have missed the reference to the location of the tomb of William of Orange. It is fitting that Vermeer's unique record of his city and its historic place should have entered the collection of Van Ruijven, his loyal Delft patron.

Although more than a century of archival research has yielded as much information about Vermeer as we have about many artists of his time, this knowledge does not tell us all we want to know. It gives us lots of his context, not much of his artistry. The archive is silent about how Vermeer came up with his novel images, how he made his paintings look like extracts of real life, how he might have spoken of his art, much less thought about it. There are no letters, journals, workshop recipes or even working drawings. To get a sense of Vermeer's mind, we have only the paintings to go on – 'only', but they are a revealing source.

'LIFE ITSELF, OR SOMETHING HIGHER' – THE CAMERA OBSCURA

Several features of Vermeer's paintings have long drawn comparisons to the effects of the photographic camera. There is the hyper-real look, the abrupt framing, the careful geometry, the telescoping of space that makes foreground figures loom unexpectedly large (fig. 29). The new intensity of interest in Vermeer after about 1860

29
Johannes Vermeer, *Officer
and laughing girl*, c. 1658-60.
Oil on canvas, 50.5 x 46 cm.
The Frick Collection,
New York.

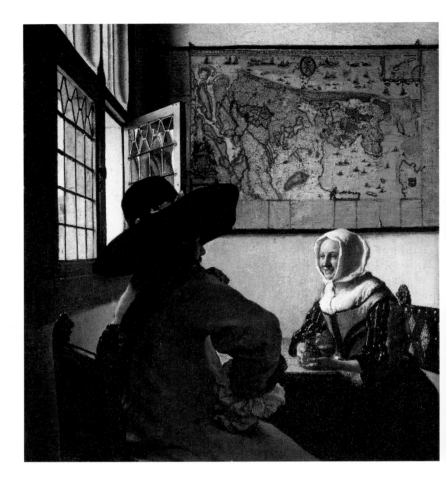

30
Camera obscura, etched
illustration from Johan
van Beverwyck, *Schat
der Ongesontheyt*, 1647.
Koninklijke Bibliotheek,
The Hague.

coincided with the development of
photography, and admiration for him
has only grown as vision-extending
technologies have proliferated.
Vermeer's photographic effects have
caused many scholars to claim that
his pictures somehow depended on
the camera obscura, the precedent
and principle of the photographic
camera.

The case is strong, and extends beyond
the phenomena already mentioned.
The camera obscura ('dark chamber')
was a relatively simple instrument
well known in 17th-century Europe.

The basic camera was a windowless chamber with a small hole in one side and a white wall opposite the side with the hole. Light entering the camera through the hole would project on to the opposite wall and produce an upside-down and reversed image (fig. 30). Most cameras were fitted with a lens in the hole to focus the image, and possibly with mirrors to correct its orientation.

Limitations to the technical perfection of the camera obscura set it apart from the modern photographic camera, and these deficiencies shaped Vermeer's uses of the instrument. 17th-century lenses did not focus with the kind of precision through the depth of field we expect even from disposable cameras today, and slight grinding irregularities caused halo-like spreading of highlights in the camera image. These minor flaws caused arresting visual effects that have been noted in Vermeer's paintings. His creation of outlines by contrasting areas of light and dark, for example,

31
Johannes Vermeer, *Girl with a pearl earring*, c. 1665-66. Oil on canvas, 46.5 x 40 cm. Royal Cabinet of Paintings Mauritshuis, The Hague.

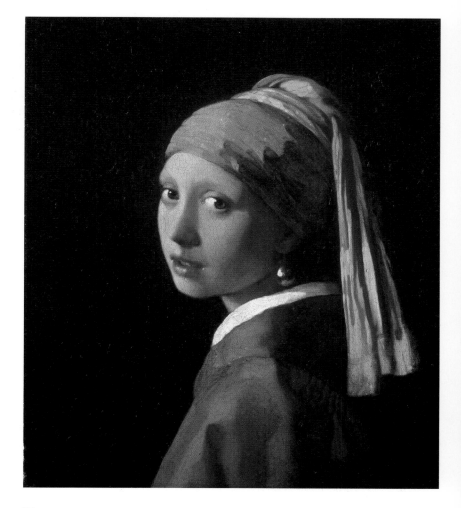

32
Johannes Vermeer,
The lacemaker, c. 1670.
Oil on canvas transferred
to panel, 24.5 x 21 cm.
Musée du Louvre, Paris.

reproduces the soft focus of early camera obscura images. This mode of drawing, favouring geometric abstraction and eschewing harsh contours, is obvious in the *Girl with a pearl earring* (fig. 31). The absence of sharp contours and presence of broad areas of light and dark suggest that Vermeer built up his forms in patches of light and dark from the very beginning. The camera obscura also produced different degrees of focus, leaving objects in foreground and background planes blurred while giving sharper images of the middle ground. Such sharp differentiation is avoided in most of Vermeer's paintings, but the effect is pronounced in

early works such as *The little street* and insistent in the late *Lacemaker* (fig. 32). *The lacemaker* also displays Vermeer's habit of applying tiny globules of white paint that mimic the spreading of pinpoint highlights seen through the camera obscura. These halo-like highlights are not apparent to the unaided eye. Vermeer's exploitation of these effects was most emphatic in early works such as *The kitchen maid*, where the white dots also texture the bread, and the *View of Delft*, where they suggest implausible reflections on to the deeply shaded boats.

Vermeer should have had no difficulty gaining access to optical technology in Delft. Perceptual instruments were the passion of his fellow townsman Anthonie van Leeuwenhoek, who famously discovered microorganisms with the newly invented microscope. Although no direct contact between Van Leeuwenhoek and Vermeer is recorded, these exact contemporaries, both baptized in 1632, must surely have met in the small city. Van Leeuwenhoek acted as executor of Vermeer's estate (though the case may merely have been assigned to him). It has been suggested that he served as the model for Vermeer's *Geographer* and *Astronomer* (fig. 33). Although the identification cannot be settled, the accurate rendition of instruments and cartographic material in both paintings confirms that Vermeer was at home in the world of natural history.

17th-century camera enthusiasts saw the instrument as a promising new tool for painters. In 1622, Huygens

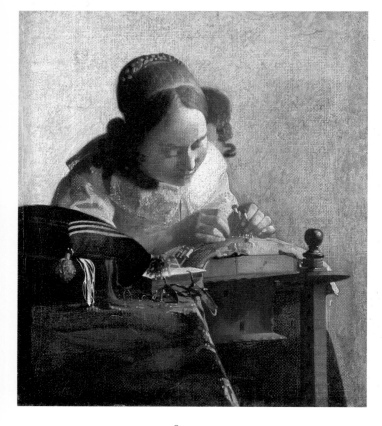

33
Johannes Vermeer,
The geographer, c. 1668-69.
Oil on canvas, 53 x 46.6 cm.
Städelsches Kunstinstitut,
Frankfurt.

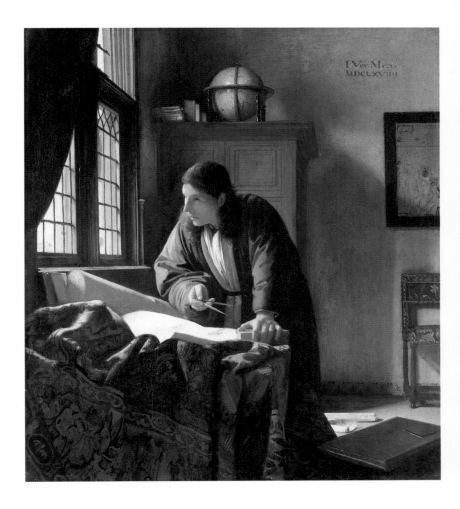

enthused that 'it is impossible to express [the camera's] beauty in words. The art of painting is dead, for this is life itself, or something higher, if we could find a word for it'. Huygens seems to taunt painting: the art is dead at the hands of the camera, and the camera image is praised as 'life itself, or something higher'. These words would have stung any ambitious painter, for representing life had been the task of easel painters since the 15th century, and now the camera, a mechanical instrument, presented real

competition in the market for lifelike images. As that market was virtually insatiable in Holland, Huygens's challenge will have been theoretical rather than urgent, but artists of Vermeer's ambition were poised to take up the gauntlet. In his treatise on painting of 1678, the painter-scholar Samuel van Hoogstraten, Fabritius's erstwhile colleague, praised the camera image as a model for lifelike painting: 'I am certain that seeing this projection in the dark will give the vision of young painters no small light, for

34
Possible arrangement of the
camera obscura for Vermeer's
Music lesson. Courtesy of Philip
Steadman.

35 >
Johannes Vermeer,
The music lesson, c. 1662-64.
Oil on canvas, 74 x 64.5 cm.
The Royal Collection, Her
Majesty Queen Elizabeth II.

La perspective curieuse as 'a very useful work for painters, architects, sculptors, engravers and all others concerned with drawing'. Niceron explained that the image projected by his camera was so accurate 'that if a painter imitates all its shapes, and if he applies to them the colours that appear so vividly, he will have a perspective as perfect as one could reasonably desire'.
Meticulous geometric analysis has suggested that Vermeer may have used the camera to set up the perspective structure of at least six of his interior paintings, tracing its faint image of a real room in his house in drawings or directly on to his canvases. When one works backward from the perspective structure of each of these paintings to the camera set-up that could have yielded such a spatial construction, it turns out that all of these pictures would have originated from projected images equal in size to the canvases on which they are painted. This result suggests that on occasion Vermeer copied actual camera projections on to canvas. It has been argued that Vermeer built a cubicle-sized camera in his studio, possibly using curtains to block the light from a window (fig. 34). Such a structure would have helped Vermeer work out such complex perspective arrangements as the furnishings in *The music lesson*, including their reflections in the mirror (fig. 35).
If Vermeer's use of the camera is obvious to us, it is because he left conspicuous traces of it: signs which, like the little white globules, sometimes made his paintings look less rather than

beside acquiring knowledge of nature, one sees here what on the whole or in general a truly natural painting ought to have.'
The camera certainly was an effective compositional device. It could suggest framings and translate a three-dimensional space into a perspective image on a flat surface without cumbersome geometric calculation. Writers on optics promoted the usefulness of the camera for the construction of geometrically correct perspective. In 1652, Jean-François Niceron published his

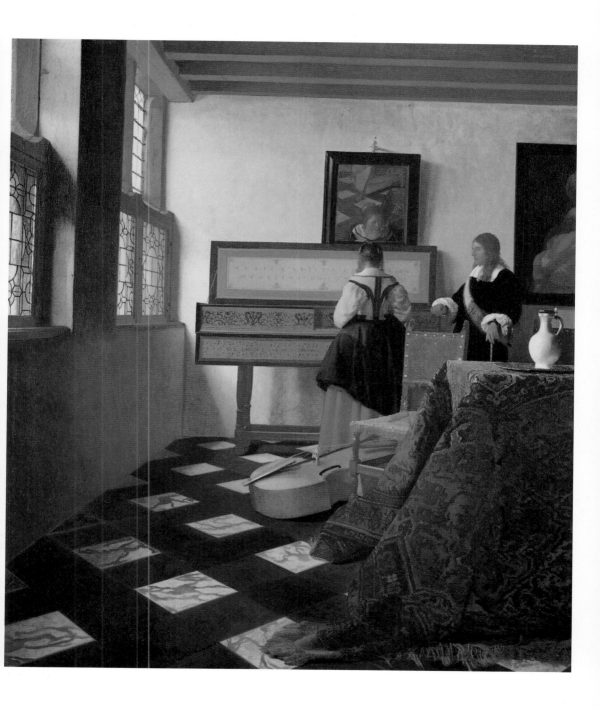

36
Johannes Vermeer,
Girl with a wineglass, c. 1660.
Oil on canvas, 77.5 x 66.7 cm.
Herzog Anton Ulrich-Museum,
Braunschweig.

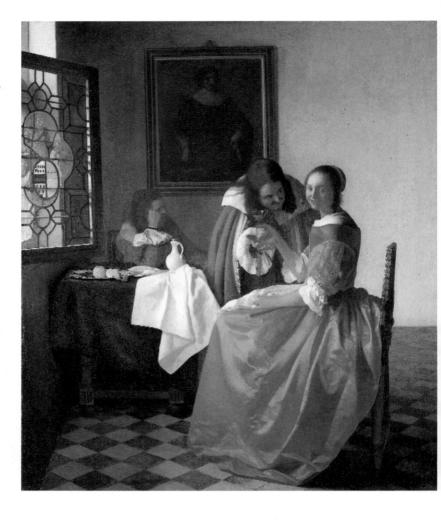

more natural. Vermeer's familiarity with the device was probably even more evident to contemporaries like Huygens, Van Berckhout and Van Leeuwenhoek. We do not know about Van Ruijven's scientific interests, but he must have known of the instrument. Vermeer's first conspicuous displays of optical knowledge coincide with his initial contacts with his patron, and Van Ruijven's purchases from Vermeer – including *The music lesson* (fig. 35) – show all the hallmarks of camera

vision. The security of his patronage may well have afforded Vermeer time to steep himself in optics.

The very modernity of the camera obscura may have stimulated Vermeer to play up its creative role in his works. His most camera-like pictures even outdo the camera image in one crucial respect. These paintings appear to freeze images that in the camera obscura would move and change, for the camera obscura was a more direct precedent for cinema than

for still photography. Vermeer occasionally emphasized the capability of painting to overcome the restlessness of camera imaging, letting milk pour down in a slow, unending trickle or keeping the lacemaker's threads tensed for ever.

Despite his optical sophistication, Vermeer engages us as an artist, not a scientist. His artistic sensibility filtered what he saw by technological means into an art distinctly his own. Subtle deviations in his paintings from optical expectation underscore this intuitively obvious point, as analysis of the *Girl with a wineglass* shows (fig. 36). Were Vermeer to have traced the precise camera projection of the room, the painting would have shown a larger casement window, a larger picture within the picture and a larger wine jar. In other words, Vermeer adjusted the laws of projective geometry so as not to let consistent perspective interfere with the viewer's concentration on his human actors, who now take centre stage. Like many contemporaries, Vermeer worked his realist techniques in order to make his images more persuasive. Focused primarily on domestic moments, his realist paintings had a chance to shape social ideals and practices as much as reflect them. In an age of confidence in the capability of perceptual technologies to reveal knowledge, Vermeer's paintings of domestic occupations may have looked just right, offering as convincing a vision of social life as our modern visual media.

WOMAN READING A LETTER — TOWARDS A SCIENCE OF THE INTERIOR

Vermeer's researches transcended optics to offer artistic statements on human identity and on the moral life. Modern novels and poems about Vermeer are not primarily about the interiors themselves, but about the people and scenes Vermeer staged in them, about the conversations between men and women or two women by themselves, and about single figures thinking. Vermeer's compelling way of representing intimacy and private thought has made him especially attractive to modern writers.

After *The kitchen maid* Vermeer painted no other pictures of women busy with their housekeeping, except for the preferred occupations of ladies of leisure, such as making lace, and reading and writing letters. And after *The procuress* he never again painted explicit scenes of mercenary love (fig. 20). These developments were not straightforward breaks in his career, however. While Vermeer did not repeat the seamy scene that is *The procuress*, he transformed that genre into subtle scenes of men and women engaged in conversation or music making. While *Officer and laughing girl* of c. 1658-60 (fig. 29) casts the swaggering cavalier and remarkably open young woman as potential, even likely lovers, the situation in the slightly later *Girl with a wineglass* is more difficult to read (fig. 36). The source of the young woman's knowing smile is not ap-

37
Johannes Vermeer,
Woman reading a letter, c. 1663-64.
Oil on canvas, 46.5 x 39 cm.
Rijksmuseum, Amsterdam.

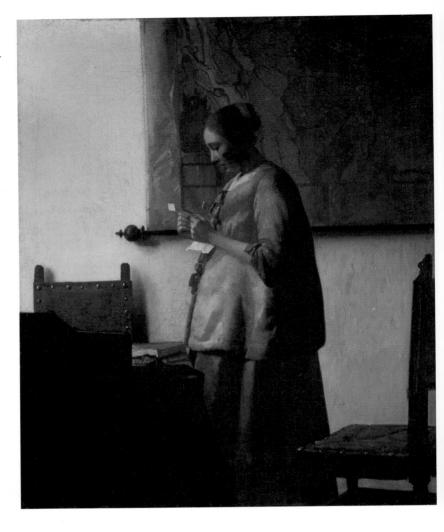

parent, and the contrast between the smarmy suitor and his melancholy male companion is unexplained. *The music lesson* of c. 1662-64 substitutes music making for wine as social lubricant (fig. 35). The image in the mirror above the virginal reveals that the young woman is looking at her companion, but the outcome of this scene is unknowable. Each member of *The concert*, painted a few years later, contributes to the private recital (fig. 18), and yet they play in the presence of the unwholesome trio in Van Baburen's *Procuress* (fig. 17), which Vermeer reproduced on the wall. This painting within the painting reminds us that, seen chronologically, Vermeer's paintings of men and women together had increasingly edited out references to physical love, to the benefit of more genteel, even Platonic rituals. Dutch society itself was actively trying to civilize itself in

38
Johannes Vermeer,
*Young woman reading a letter
at an open window*, c. 1657.
Oil on canvas, 83 x 64.5 cm.
Staatliche Kunstsammlungen,
Gemäldegalerie Alte Meister,
Dresden.

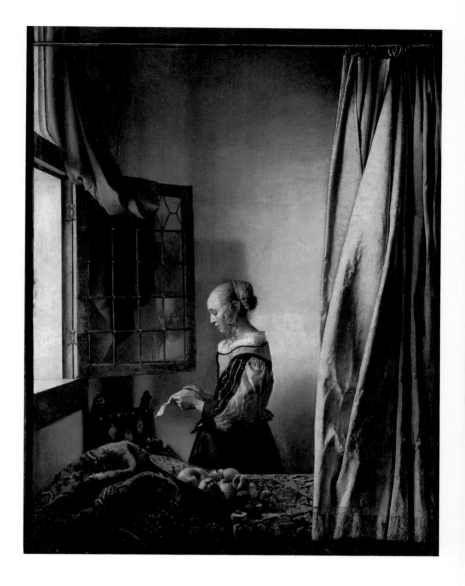

this way, trying to regulate prostitution and other extramarital sexual activity, though apparently without much success. Vermeer's trajectory from his own *Procuress* (fig. 20) to *The concert* exemplifies this hoped-for transformation. As the nagging presence in that painting of Van Baburen's *Procuress* suggests, it also acknowledges the ultimate impossibility of a purely spiritual love.

Vermeer's first picture of a woman alone after *The kitchen maid* was probably the Rijksmuseum's *Woman reading a letter* (fig. 37), painted about 1663. This painting of an apparently pregnant woman in a solitary mental act did not come out of nowhere, for he had already painted *Young woman reading a letter at an open window* (fig. 38). Vermeer gave the woman in blue the

39
Gerard ter Borch,
*Girl in peasant costume
(probably Gesina ter Borch,
the painter's half-sister)*, c. 1650.
Oil on panel, 28 x 23 cm.
Rijksmuseum, Amsterdam.

profile view and downcast eyes of his earlier letter reader. With averted gaze and limited facial expression, profile views effectively communicate interior absorption; like Vermeer, Gerard ter Borch often exploited this point (fig. 39). While we technically see more of Vermeer's early *Young woman reading a letter at an open window* through her reflection in the window, the phantom image offers no more than another version of her downcast gaze. In the *Woman reading a letter*, Vermeer did not go in for the conspicuous virtuosity of his first letter reader, forgoing also the splendid illusionist curtain and the full description of the wool table carpet and the fruit.

The colour scheme of the *Woman reading a letter*, limited to blues, whites and yellows, and the handsome geometry of the composition force us to focus on the woman and her act of reading. Occupying the large centre of the painting's surface, the woman's blue jacket, painted in expensive ultramarine, is the main motif from which the other parts of the composition are developed. Even the white walls and the shadows on them have a bluish cast, which Vermeer prepared by mixing ultramarine particles into the lead white paint. Ochres in low saturation are the foil to this study in high-keyed blues. This colour scheme is essential to the coherence of Vermeer's composition. The white wall surfaces balance similarly (but never identically) shaped areas of colour around the central woman. The long vertical rectangle on the upper left, for example, finds a relaxed counterpart in the area below the map on the lower right. Vermeer tailored this equivalence by slimming the bell shape of the woman's jacket and by extending the map's outline to the left. This kind of geometric play recurs in smaller subsystems throughout the painting. The Mondrian-like alternation of rectangles of white wall and bars of dark wood that represents the chair on the lower right is one such place. Most brilliantly economical of all are the two patches of creamy white that make up the woman's letter: a precise, tiny lozenge above her hands and

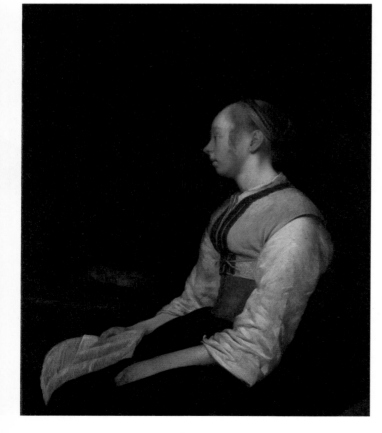

40
Balthasar van Berckenrode,
Map of Holland and West-
Friesland, 1620. Engraving,
published by Willem Jansz
Blaeu. Westfries Museum,
Hoorn.

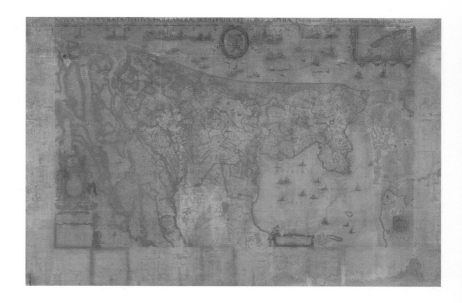

a slightly wider parallelogram below read together as a folded letter seen in foreshortening. The high-keyed colour of this passage and its colouristic approximation to the woman's ochre face make us attend to what she is doing – reading a letter. Vermeer's representation of the map is indicative of his efforts to avoid distraction from this central motif. While its exact model was a map of Holland by Balthasar van Berckenrode, published in 1620 by Willem Jansz Blaeu (fig. 40), he did not want us to linger over that fact. In *Officer and laughing girl* he had represented this map in luxuriant colour and anecdotal detail, including lettering (fig. 29). So clear is the map in this painting, that its identity in *Woman reading a letter* can be confirmed only by comparison to the earlier work. It has been suggested that the jumble of rivers

and borders on the map represents the woman's tangled thoughts, possibly occasioned by her pregnancy, but given the painting's extreme repose this reading seems too literal. The painting rather encourages us to regard the act of reading and perhaps to think about its relation to the fundamental privacy of thought.

In 17th-century philosophy and visual representation, silent reading, one of the most introspective of activities, was a potent image for thought and self-consciousness. It was especially so in the Dutch Republic, where a primarily Protestant culture of the word had prompted unparalleled rates of literacy and publication, spurred by the success of an early capitalist publishing industry. In contrast to the traditional Catholic Church, the Protestant Reformation had asserted the need for lay believers to read the Bible for them-

47

statements in the Dutch Republic. Private diaries, journals and letters, soul-searching poems and prayers, and not least self-portraits were avidly practised genres, popular far beyond their growing role in the aristocratic culture of the Renaissance. Rembrandt's self-portraits (on average, more than two survive for every year of his career) chronicled his visual appearance and preoccupations in unprecedented detail. Vermeer is likely to have known at least one of Fabritius's self-portraits in Rembrandt's vein, and some of Rembrandt's self-portrait prints. Vermeer's place in this early modern history of introspection and self-consciousness is restrained compared to Rembrandt's outspoken and well-circulated exercises. Unlike Rembrandt, who signed most of his works boldly with his first name, Vermeer signed less obtrusively and less often, favoring IVMeer or his monogram. Scholars have tried to see his self-portraits in the figure looking out from the left margin of *The procuress* (fig. 20) and in the similarly attired painter who presents his back to us in *The art of painting* (fig. 49). The argument cannot be proved or disproved, and we can conclude that, if Vermeer wanted us to see him as the painter in these works, he avoided Rembrandt's conspicuous displays of personality. Yet Rembrandt's representations of the human interior did affect him. Rembrandt's most famous print of a man in thought, the etching of Jan Six (fig. 41), may be the closest precedent for Vermeer's thinking women and men. Six, a wealthy

41
Rembrandt, *Jan Six*, 1647. Etching, engraving and drypoint, 244 x 191 mm. Rijksmuseum, Amsterdam.

selves, in the vernacular, and without priestly mediation. René Descartes, the most systematic philosopher of human self-awareness, did much of his thinking and writing about such matters while in exile in Haarlem. There, in 1633, he published the famous statement of thought as the irreducible fact of human existence: 'I think, therefore I am'. Few Dutch investigations of introspection matched Descartes in rigour, but that self-awareness was considered a virtue is evident in the sudden proliferation of first-person

connoisseur of Van Ruijven's ilk, poses as the paragon of the humanist scholar, absorbed in reading and thought, turned away from the window that signifies the world outside his private, deeply shaded study. While Vermeer's female letter readers are removed from the world of collecting and bookish knowledge that constitutes the man Six, they appear to acknowledge their genealogical descent from Rembrandt's etching. They owe to it their stillness, their placement by windows that bring real as well as metaphoric light, and their undistracted concentration on the written word. 'I read, therefore I think' might serve as a caption to these works.

Marked stylistic changes accompanied the shift from the domestic materiality and sexual explicitness of Vermeer's early paintings to the virtuous thoughtfulness and amorous gentility of his later works. The emphasis in these later paintings on mental faculties and elegant ritual goes along with a newly smooth surface finish, a more restricted but well-modulated palette and more insistent geometric design. The pronounced textures of bread and bricks, carpets and curtains of the early paintings are avoided. It is as if Vermeer were trying to find more optical and abstract forms to express the capacity for thought his figures appear to project. The painter's compositional balancing act structures the space of thought in paintings such as the *Woman reading a letter*.

THE LOVE LETTER – VERMEER AND MODERN ALLEGORY

After the economical, distilled quality of the *Woman reading a letter*, the Rijksmuseum's *Love letter* of about 1667-69 announces a return to the anecdotal, with a complex perspective structure, a fuller colour spectrum, a set of explicit narrative hints (fig. 42). We are peeking through a doorway, beyond a tapestry that has been pulled up for our benefit, into a reception room handsomely appointed with marble floor tiles, landscape paintings, a classically structured fireplace and a gilt leather wall hanging. This is a house decorated to the latest standards of design. In it, a lady in ermine-trimmed satin has interrupted her cither playing – a genteel avocation – to receive a letter from her maid. The maid's smile and stance, with arm bent in a sign of self-assurance, may indicate her knowledge of the letter's sender or content. Her demeanour or words have disconcerted the lady, for she casts one of Vermeer's most telling glances.

This painting sits oddly within Vermeer's output of the 1660s. It appears to respond to growing market preferences for detailed interiors and titillating scenarios, and it may be significant that this painting did not go to Van Ruijven. The successful paintings of Caspar Netscher, Ter Borch, Metsu and Frans van Mieris (fig. 45) offered fine descriptions of satin and ermine, marble and porcelain, silver and pearls, and they excelled at amorous innuendo.

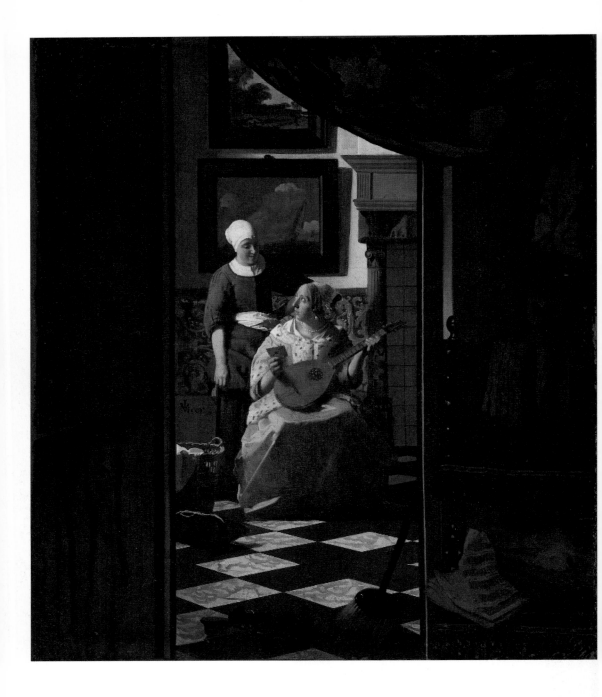

< 42
Johannes Vermeer, *The love letter*, c. 1667-69. Oil on canvas, 44 x 38.5 cm. Rijksmuseum, Amsterdam.

43 ∨
Samuel van Hoogstraten, *The slippers*, 1658. Oil on canvas, 103 x 71 cm. Musée du Louvre, Paris.

44 >
Pieter de Hooch, *Couple with a parrot*, 1668. Oil on canvas, 58 x 71 cm. Wallraf-Richartz-Museum, Cologne.

In this same period Samuel van Hoogstraten and Emanuel de Witte perfected the virtuoso perspective representation of urban homes. Van Hoogstraten's *Slippers*, painted in 1658, is such an exercise – a virtual still life of an interior activated by unstated human presence (fig. 43). The contrast between the frivolous slippers, perhaps discarded in haste, and the broom resting beside the door-frame offers the viewer great opportu-nities for visual scrutiny and narrative speculation. Ending and extending our perspective view, a painting by Ter Borch of a woman in satin, seen from the back, withholds any imme-diate answers.

Van Hoogstraten's clever picture may have been a source for Vermeer's *Love letter* and for De Hooch's *Couple with a parrot* (fig. 44). Painted probably after *The love letter*, De Hooch's paint-ing catalogues all the market attrac-

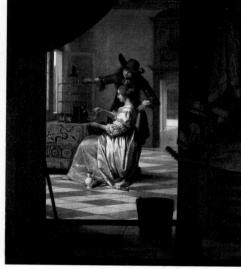

45
Frans van Mieris I,
Woman writing a letter, 1680.
Oil on panel, 25 x 20 cm.
Rijksmuseum, Amsterdam.

abstract and the modelling of the volumes more schematic than in the work of his peers (fig. 45). And unlike the perspective in their paintings, Vermeer's perspective does not pull us immediately into the scene, for the vanishing point lies on the chair-back in the dark foreground room, thus diverting our gaze temporarily.

Whatever the precise relationship of these three paintings, it is obvious that Vermeer deliberately placed the painting in relation to the pictorial tradition of women writing or receiving letters. This theme engaged him on five other occasions (see figs. 37, 38), but *The love letter* offers by far the fullest story and decorative description. His only other painting of a woman receiving a letter in her maid's presence is more economical in framing, setting and colour scheme, and its gestural language is reticent (fig. 46). With its outspoken gestures and two paintings on the wall, one a seascape, the other an idyllic landscape, *The love letter* actively contributes to the history of its theme. When women were represented with letters, the content of the missive was invariably understood to be amorous. In the 1630s, Dirck Hals exploited this consensus in a painting of a woman tearing up a letter before a painting of a boat caught in a storm (fig. 47) – presumably an indication of the tempestuous relationship between the woman and the author of the letter. In another painting by Hals, a woman displays a letter while sporting a grin as wide as the Cheshire Cat's (fig. 48). The calm seascape

tions of 1660s interior painting. To a viewer familiar with Van Hoogstraten's painting, the conversation of a man and a woman, over wine and about a parrot, might also read as De Hooch's retrospective rendition of the moment that preceded the one recorded in *The slippers*. Vermeer's *Love letter* does not connect as neatly to these two paintings (though a fertile imagination might read it as the morning after). As in the *Woman reading a letter*, its rendering of textures is much more

46
Johannes Vermeer,
Mistress and maid, c. 1666-67.
Oil on canvas, 92 x 78.7 cm.
The Frick Collection, New York.

47
Dirck Hals,
Woman tearing up a letter, 1631.
Oil on panel, 45.5 x 56 cm.
Landesmuseum Mainz.

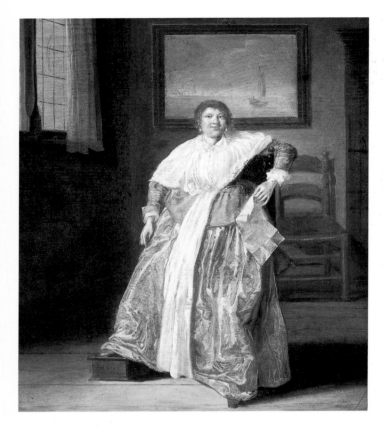

48
Dirck Hals, *Woman with a letter*, 1633. Oil on panel, 34.3 x 28.3 cm. John G. Johnson Collection, Philadelphia Museum of Art, Philadelphia.

49 >
Johannes Vermeer, *The art of painting*, c. 1667-68. Oil on canvas, 120 x 100 cm. Kunsthistorisches Museum, Vienna.

behind this lady suggests smooth sailing in love. In Dutch society, maritime conditions offered standard metaphors for the shifting fortunes of love. As so often in his art, the paintings in Vermeer's picture do not reveal the outcome of this tale. While the sailing vessel is not in imminent danger of capsizing, the dark clouds and foreground shadow do not inspire confidence. In one of Vermeer's proto-cinematic moments, we cannot quite know what the next frame will show. Vermeer's attempt to meld the love letter theme with fashionable interior design and complex perspective has

struck many as not entirely satisfactory. In 1892, when the painting came up for sale, Abraham Bredius, director of the Mauritshuis, compared it unfavourably to *The little street* and *The kitchen maid*; the painting's attribution to Vermeer has occasionally been questioned since then. The experimental character of the work may have caused this unease, but that kind of adventurousness is characteristic of Vermeer's art. Unlike Dirck Hals, Vermeer represented an allegory of the vagaries of love in elaborate contemporary terms. This mode of painting is what the painter Gerard de Lairesse described as *modern* in his *Great book of painting* of 1707. De Lairesse used the term *modern* in unfavourable contrast to *antiek*. While the modern was hopelessly subject to fashion and incapable of lending lasting significance to any painting, the *antiek*, best exemplified in classicist history painting, stood for the timeless and the universally valid. By casting an allegory in modern terms, Vermeer joined his contemporaries in contravening a long tradition of allegory in antique guise. But he came to the love letter theme late, and by about 1670 it may have been exhausted for ambitious modern painting, having become more of a vehicle for riveting textural description in the work of Van Mieris and others (fig. 45).
The effort to shape modern allegory was unquestionably successful in the nearly contemporary *Art of painting* (fig. 49), which shares perspectival and colouristic features with *The love letter*. Depending on what date one

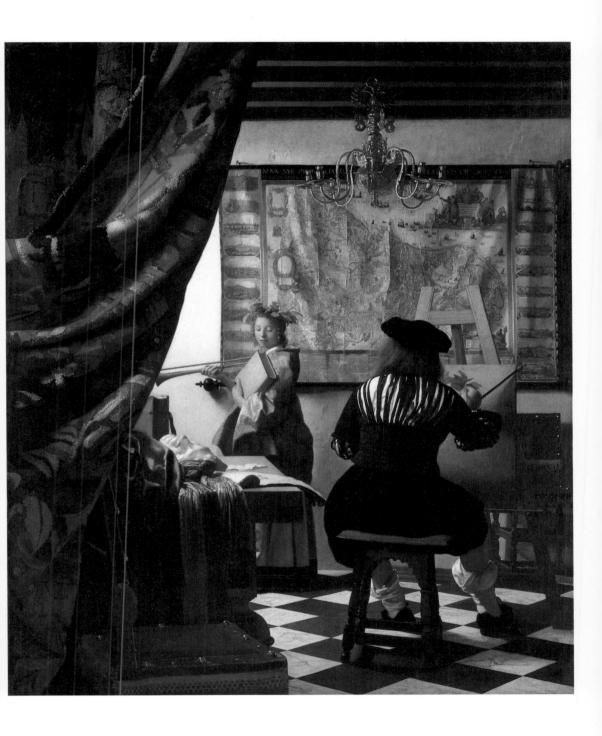

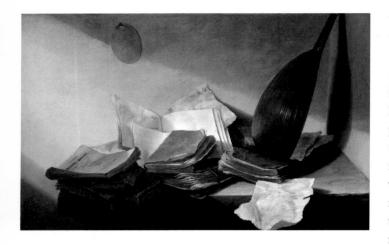

50
Jan Davidsz de Heem,
Still life with books, c. 1628.
Oil on panel, 26.5 x 41.5 cm.
Rijksmuseum, Amsterdam.

accepts for these paintings, *The love letter* may even have prepared the way for the spying perspective of Vermeer's boldest modern picture. *The art of painting* renders the trappings of allegory – laurels, trumpets and outmoded costumes – as props in a contemporary studio, where a painter paints his muse in a modern setting. As interpreters of this painting have argued in various ways, the result is a novel allegory of painting, and of its relations to Clio, the muse of history on which it depends, and to Fame, art's advocate. Vermeer's signature here signals his control over this modern experiment, placed on the internal border of the map. The painting's mesmerizing hold on viewers today gives the lie to De Lairesse's assumption that the modern Dutch mode could not stand the test of time.

VERMEER'S LEGACY AND THE RIJKSMUSEUM

The art of painting, which Vermeer kept in his studio, is the summation of his career as a brilliant craftsman and painter of uncommon visual sensitivity. Vermeer's patronage arrangement possibly allowed him to become what we might call a research artist, making small discoveries from work to work, setting aside projects and returning to them when new material could be brought to bear, usually succeeding in his experiments but occasionally, perhaps, accepting partial failure.

Through his art, Vermeer lived the maxim of Samuel van Hoogstraten, who held that 'learnedness is the ornament of painters'. Well before Vermeer, Netherlandish painters had composed pictures on this theme. Jan Davidsz De Heem's *Still life with books* (c. 1628; fig. 50) is no mere meditation on the vanity of human knowledge; a palette suspended from a nail in the back wall (a rare white back wall to precede Vermeer) hints at the painter's awareness of the intellectual character of his art. Rather than the bookish learning of artist-writers such as Van Hoogstraten, however, Vermeer's was a painterly erudition. He owned several dozen books, and they must have included works on perspective and optics. But what makes Vermeer's art interesting is the way in which it appears to articulate thought in pictorial terms. In this sense, Vermeer stood in a relation to the world like that of

51
Willem Claesz Heda,
Still life with gilt goblet, 1635.
Oil on panel, 88 x 113 cm.
Rijksmuseum, Amsterdam.

the geographer in his study (fig. 33), a scholar quiet and intense, looking to the visible world so that he might translate it into pictures, pictures at once mental and visual, pictures that privilege the visual sign over the word, pictures that let us discern more than we knew before.

The knowledge gained may seem quite plain, for Vermeer's paintings let us look anew at a strikingly familiar, ordinary world. Vermeer was not unique in this interest in the daily world of objects, or the world as an object of

intense scrutiny and contemplation. De Hooch's similar interest in the abstract play of geometric forms has already been noted (figs. 2, 6); similar visual games activate the surfaces of the varied still life compositions of Willem Claesz Heda (fig. 51). In Heda's *Still life with gilt goblet* of 1635, deliberate but inconspicuous contrasts of forms and surface finishes make for sustained visual interest: tall versus short, upright versus reclining, shiny versus dull, transparent versus opaque, in almost endless variety. As in Ver-

52
Jan Ekels II, *A writer trimming his pen*, 1784. Oil on panel, 27.5 x 23.5 cm. Rijksmuseum, Amsterdam.

meer, these patterns suggest themselves in part because the colour scheme is restricted to avoid distraction.

Vermeer's ability to render the mundane worthy of attention, his optical hyper-precision and his tendency toward abstraction made his art relevant for later generations of artists and viewers, particularly in the Netherlands. Although it is often assumed that Vermeer was forgotten from his death in 1675 until his rediscovery in the 1860s, it was the extent, rather

than the import, of his work that became obscured. In an age before photographic reproduction and motorized transport, paintings by De Hooch, Metsu or Jacob Vrel were attributed to Vermeer about as often as their works went under his name. 18th- and 19th-century paintings in the Rijksmuseum show that Vermeer's innovations became leading models for later Dutch painters, even if Vermeer's paintings went by the names of more productive artists. Jan Ekels II, for example, combined elements of Metsu and Vermeer to arrive at his *Writer trimming his pen* (1784; fig. 52).

Reproductions and ease of travel facilitated the reconstitution of Vermeer's oeuvre in the second half of the 19th century, an effort spearheaded by the art critic and broker Théophile Thoré-Bürger. The *View of Delft* and *The little street* were crucial starting points for this work, for unlike Vermeer's history paintings and interiors these signed exterior scenes had never been dissociated from his name. The paintings circulated in copies and texts as particularly famous works by the master, even in the 18th century when they were mostly out of sight. In 1822, when the Dutch King William I bought the *View of Delft* for the Royal Cabinet of Paintings in the Mauritshuis, the painting became the first Vermeer widely accessible to the public; in 1800 *The little street* had entered the well-known collection of Pieter van Winter, eventually joined by marriage to the equally prestigious Six collection. As 19th-century Dutch painters turned

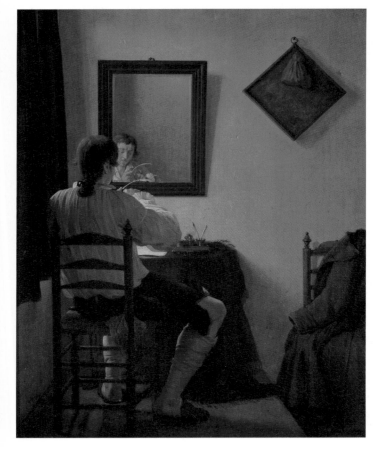

53
Wouter J. van Troostwijk,
The Raampoortje, Amsterdam,
1809. Oil on canvas,
57 x 48 cm. Rijksmuseum,
Amsterdam.

to the Golden Age in a conscious effort to build a new national school of painting, the *View of Delft* became a template for the most varied landscapes, from romantic winter scenes with a soft finish to gritty city scenes painted in the rough style of 19th-century realism (figs. 53). Most painters looked to Vermeer for colouristic refinement and paint handling as well as composition. The half-dry, sandy

texture of the paint surface in Jacob Maris's *The bridge* suggests his close study of the deft touches in Vermeer's early cityscapes (fig. 54).

In 1876, the Mauritshuis acquired its second Vermeer, the early *Diana and her nymphs.* Five years later, the iconic *Girl with a pearl earring* was lent to the same museum, as a promised bequest that was finalized in 1902. In the same period international collectors vied for

54
Jacob Maris, *The bridge*, 1879.
Oil on canvas, 41 x 72 cm.
Rijksmuseum, Amsterdam.

any available paintings by the newly famous Vermeer, and the Rijksmuseum had some catching up to do. This process began in 1885 when the recently built Rijksmuseum received *Woman reading a letter* as part of the Van der Hoop bequest, deposited on long term loan by the City of Amsterdam. A concerted national effort to buy important works of art at risk of export was by then under way, led by the Vereniging Rembrandt, which was founded for the purpose in 1883. In its first remarkable success, the association bought *The love letter* for the Rijksmuseum in 1892, having struck a secret deal with the Dutch owner before a sham auction in which the association 'outbid' several English collectors.

The kitchen maid and *The little street*, both in the Six collection, took more

doing. They came up for sale in 1907 and 1921 respectively, years when the supply of Vermeers had dried up and any painting by the master attracted intense international competition. In 1907 the Six family gave the Dutch government the right to negotiate purchase of *The kitchen maid*; the deal involved a lot of wrangling but the purported export threat was remote (fig. 9). *The little street* was a different matter. After the Dutch government proved unable to meet the sale price set by Professor Jan Six, the art historian put the painting up for auction in 1921. It did not realize the target price, but rumour soon had it that the Louvre would acquire the picture as its second Vermeer (*The lacemaker* had entered its collection in 1870). Sir Henry Deterding, the President

55
Detail of fig. 1,
The little street, c. 1657-58.

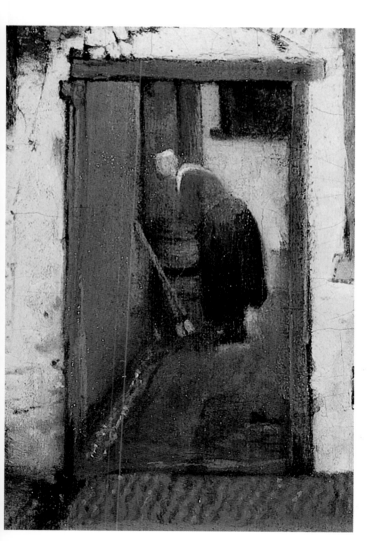

of the Royal Petroleum Company then resident in London, narrowly defeated the Louvre's efforts by sending an assistant on a hasty mission to Six. After an open-air plane trip from an English airstrip to a Dutch meadow and an unannounced nocturnal visit to Six, the emissary managed to secure the right of first refusal so that Deterding might buy the painting for the Rijksmuseum. Deterding's generosity was celebrated as an act of Dutch patriotism: a prominent newspaper found it proof 'that the donor, despite many years spent abroad, has remained Dutchman in marrow and bone'.

It is curious that buying and donating a Vermeer should have amounted to a verification of Dutchness, for modern viewers have seen him as an artist of universal appeal. His first modern champion, Thoré-Bürger, was a French exile and a self-conscious cosmopolitan, who adopted the German pseudonym W. Bürger to suggest *Weltbürger*, citizen of the world. Exhibitions of his work attract record crowds from New York to Nagoya; novelists and artists the world over rework Vermeer. An Italian president of the international war crimes tribunal in The Hague seeks out Vermeer as a humane antidote to records of depravity. Vermeer's art arose in the Dutch Republic, and could have done so only there, but it now belongs to us all. In the Rijksmuseum, we get to know Vermeer under both auspices.

Acknowledgements

Less celebrated than Rembrandt in life, but surely as famous as the Amsterdam master now, Vermeer has been the subject of prodigious scholarship and art criticism for over a century. Any writer on Vermeer rapidly accrues debts to the many products of both modes of writing; grateful mention of the formative works for this publication can but partially discharge mine. Key works are listed here alphabetically by author. For the recent, compelling identification of the buildings in Vermeer's *Little street*, I turned to Philip Steadman's online essay of 2001; in 1989, Michael Montias convincingly identified Vermeer's principal patron; Walter Liedtke's book of 2000 and exhibition catalogue of 2001 have brought out Delft's artistic culture in rich relief; for Vermeer and the camera obscura, I benefited greatly from the works of Arthur Wheelock and from Steadman's book of 2001; and

Jørgen Wadum set out his findings on Vermeer's perspective technique in the exhibition catalogue *Johannes Vermeer* (1995) and in Gaskell & Jonker 1998.

Svetlana Alpers, *The art of describing. Dutch art in the 17th century*, Chicago 1983

Daniel Arasse, *Vermeer. Faith in painting*, Princeton 1994

Albert Blankert et al., *Vermeer of Delft*, vol. 30, Oxford 1978

Celeste Brusati, *Artifice and illusion. The art and writing of Samuel van Hoogstraten*, Chicago/London 1995

H. Perry Chapman, 'Women in Vermeer's home. Mimesis and ideation', *Nederlands Kunsthistorisch Jaarboek* 51 (2000), pp. 237-271

Alan Chong, *Johannes Vermeer. Gezicht op Delft*, Bloemendaal 1992

Wayne Franits, *Paragons of virtue. Women and domesticity in seventeenth-century Dutch art*, Cambridge/New York 1993

Wayne Franits (ed.), *The Cambridge companion to Vermeer*, New York 2001

Ivan Gaskell, *Vermeer's Wager. Speculations on art history, theory and art museums*, London 2000

Ivan Gaskell & Michiel Jonker (eds.), *Vermeer studies*, Washington 1998

Lawrence Gowing, *Vermeer*, London 1952

Christiane Hertel, *Vermeer. Reception and interpretation*, Cambridge/New York 1996

Martha Hollander, *An entrance for the eyes. Space and meaning in seventeenth-century Dutch art*, Berkeley 2002

Johannes Vermeer, exhib. cat. Washington (The National Gallery of Art) and The Hague (Mauritshuis), Zwolle 1995

Michiel C.C. Kersten, Daniëlle Lokin & Michiel C. Plomp, *Delft masters, Vermeer's contemporaries. Illusionism through the conquest of light and space*, exhib. cat. Delft (Stedelijk Museum Het Prinsenhof), Zwolle 1996

Walter Liedtke, *Architectural painting in Delft. Gerard Houckgeest, Hendrick van Vliet, Emanuel de Witte*, Doornspijk 1982

Walter Liedtke, *A view of Delft. Vermeer and his contemporaries*, Zwolle 2000

Walter Liedtke et al., *Vermeer and the Delft school*, exhib. cat. New York (The Metropolitan Museum of Art) and London (National Gallery), New Haven/London 2001

John Michael Montias, *Artists and artisans in Delft. A socio-economic study of the seventeenth century*, Princeton 1982

John Michael Montias, *Vermeer. A web of social history*, Princeton 1989

John Michael Montias, 'A postscript on Vermeer and his milieu', *The Hoogsteder Mercury* 12 (1991), pp. 42-52

John Nash, *Vermeer*, London 1991

Edward Snow, *A study of Vermeer*, Berkeley/Los Angeles/Oxford 1994

Philip Steadman, *Vermeer's camera. Uncovering the truth behind the masterpieces*, Oxford/New York 2001

Philip Steadman, 'A photograph of "The Little Street"', online essay of 2001, *www.vermeers-camera.co.uk/essayhome.htm*

Peter C. Sutton, *Pieter de Hooch. Complete edition with a catalogue raisonné*, Oxford 1980

Peter C. Sutton, *Pieter de Hooch, 1629-1684*, exhib. cat. Hartford (Wadsworth Atheneum Museum of Art) and Dulwich (Dulwich Picture Gallery), New Haven/London 1998

P.T.A. Swillens, *Johannes Vermeer. Painter of Delft 1632-1675*, Utrecht/Brussels 1950

Mariët Westermann, *A worldly art. The Dutch Republic, 1585-1718*, New York 1996

Mariët Westermann et al., *Art and home. Dutch interiors in the age of Rembrandt*, exhib. cat. Newark (The Newark Museum) and Denver (Denver Art Museum), Zwolle 2001

Arthur K. Wheelock Jr, *Perspective, optics, and Delft artists around 1650*, New York 1977

Arthur K. Wheelock Jr, *Jan Vermeer*, New York 1988 (2nd ed.)

Arthur K. Wheelock Jr, *Vermeer and the art of painting*, New Haven 1995

Bryan Jay Wolf, *Vermeer and the invention of seeing*, Chicago/London 2001

Mariët Westermann is Director and
Professor of Fine Arts at the Institute of
Fine Arts, New York University.

Author
Mariët Westermann

Desk editing
Lynne Richards, Seaford (England)

Photography
Department of Photography, Rijksmuseum,
and other institutions mentioned in the cap-
tions, to which the following should be added:
fig. 11 bequest of Benjamin Altman, 1913;
fig. 14 gift of Mrs Gordon A. Hardwick and
Mrs W. Newbold Ely in memory of Mr and
Mrs Roland L. Taylor; fig. 17 M. Theresa B.
Hopkins Fund; fig. 18 photo: Bridgeman
Art Library; fig. 20 photo: Klut/SDO; fig. 21
photo: Jaap Oldenkamp; fig. 22 photo: Bild-
archiv Preussischer Kulturbesitz, Berlin –
Elke Walford; fig. 26 photo: The Metro-
politan Museum of Art, New York; fig. 32
photo: RMN – R.J. Ojeda; fig. 33 photo:
Artothek, Weilheim – Blauel/Gnamm;
fig. 34 from: Philip Steadman, *Vermeer's
camera. Uncovering the truth behind the master-
pieces*, Oxford University Press, 2001; fig. 36
photo: Bernd-Peter Keiser; fig. 38 photo:
Klut/SKD; fig. 43 photo: RMN – Gérard
Blot; fig. 44 photo: Rheinisches Bildarchiv,
Cologne; fig. 47 photo: Ursula Rudischer

Design
Berry Slok, bNO

Printing
Waanders Printers, Zwolle

© Copyright 2004 Uitgeverij Waanders b.v.,
Zwolle, and Rijksmuseum, Amsterdam

ISBN 90 400 8817 9
NUR 646, 654

For more information on the activities of
the Rijksmuseum and Waanders Publishers,
please visit www.rijksmuseum.nl
and www.waanders.nl